IDENTITY

ROCKPORT

First published in the United States of America by
Rockport Publishers, Inc.
33 Commercial Street
Gloucester, Massachusetts 01930-5089
Telephone: (978) 282-9590
Facsimile: (978) 283-2742
www.rockpub.com

ISBN 1-56496-665-8

10 9 8 7 6 5 4 3 2 1

Design: Stoltze Design
Photo: Brandon Blangger

Printed in China.

graphicIDEA
resource

GLOUCESTER MASSACHUSETTS

ROCKPORT PUBLISHERS

IDENTITY

Building Image Through Graphic Design

Dianna Edwards and Ted Fabella

IDENTITY

Building Image Through Graphic Design

Who are you? It may seem like the easiest question in the world. But as thoughtful people know, it is anything but easy to condense the complex web of culture and values and character that makes us who we are into something other people can easily understand.

This is what designers of corporate identity must do every day. And it is demanding work.

Long before the word "branding" entered the lexicon, corporate identity was shaping the perceptions of brands great and small. And to paraphrase Freud (who paraphrased Napoleon), "perception is destiny."

This is especially true in today's global marketplace where only visual communication can easily transcend the barriers of language.

Corporate identity is the graphic representation of who you are. Image is how you are perceived. Brand is everything rolled into one: who you are, what you stand for, what you value, and what you disdain.

It all begins, please note, with corporate identity.

To do corporate identity well calls for the soul of an artist and the patience of a reptile. There is no detail too small to escape scrutiny, because every detail matters. What you do, as well as what you do not do.

The designers featured in this collection understand. Some, like Jack Anderson and Debra Sussman and Keith Bright, have spent their careers studying the nuances of corporate identity.

Others, like Stefan Sagmeister and Kan Tai-Keung and Catherine Zask, bring to corporate identity work other specialties, other philosophies, other great gifts.

The work here is wonderfully diverse. There are companies of every description, budgets of every magnitude, and designers from all over the world.

Whatever the parameters, the challenge will always be the same. To answer Who are you? in a voice that rings clear and true.

Dianna Edwards

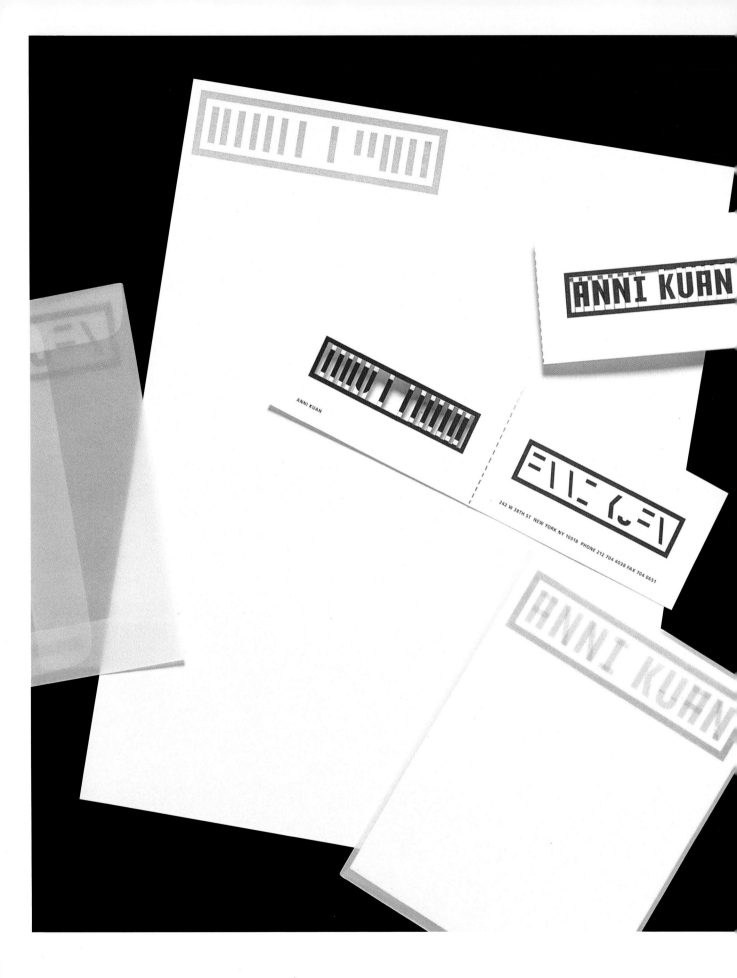

ANNI KUAN

ANNI KUAN

242 W 38TH ST NEW YORK NY 10018 PHONE 212 704 4038 FAX 704 0651

ANNI KUAN

STEFAN SAGMEISTER FOR ANNI KUAN

CLIENT	*Anni Kuan Design*
DESIGN	*Sagmeister Inc.*
ART DIRECTOR	*Stefan Sagmeister*
DESIGNERS	*Stefan Sagmeister, Hjalti Karlsson*

Sagmeister's work for fashion designer Anni Kuan is a remarkable example of a strong brand message conveyed across all media. The identity is driven by interactivity. Just as Kuan fashions components into a whole, applications must be "assembled" for full impact. (Folding the business card together reveals the name, for instance.) Advertising and exterior signage is similarly stylish and avant-garde.

CLIENT *U.S. Cigar*
DESIGN *Hornall Anderson Design Works, Inc.*
ART DIRECTOR *Hornall Anderson Design Works, Inc.*
DESIGNERS *Larry Anderson, Mary Hermes, Mike Calkins, Michael Brugman*

Hornall Anderson's reputation for beautiful, strategically focused identity is well founded. This work for U.S. Cigar speaks of both tradition and sophistication. The logo is a nod to the history of cigar packaging. The color and textural palettes evoke images of fine broadleaf tobaccos.

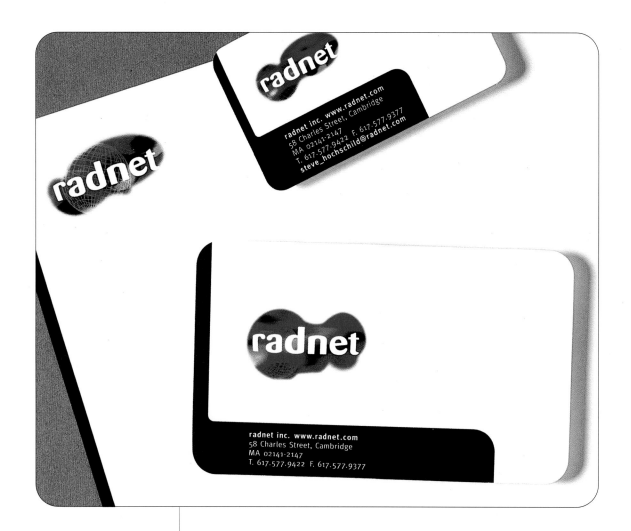

RUSSELL, INC. FOR RADNET

CLIENT *Radnet, Inc.*
DESIGN *Russell, Inc.*
ART DIRECTOR *Bob Russell*
DESIGNER *Laura Wills*

Multicolored, undulating shapes and textures as fluid as the Internet itself form the basis of this high-tech identity. As an icon, the globe has become so familiar it could easily be overlooked. Here, however, it is handled deftly; quietly evoked as a backdrop for the logotype.

SINCE 1951

U.S. CIGAR

SALES, INC.

SALES AND MARKETING OFFICE

Phone: 425·488·1133

Fax: 425·488·4688

14111 NE 145th Street, Woodinville, Washington 98072

SINCE 1951

U.S. CIGAR

SALES, INC.

CUSTOMER SERVICE AND DISTRIBUTION CENTER

6904 Parke East Boulevard
Tampa, Florida 33610

TO:

SINCE 1951

U.S. CIGAR

SALES, INC.

ROBIN STRUYVENBERG
Director of Cigar Marketing

14111 NE 145th Street, Woodinville, WA 98072

P. 425·488·1133 F: 425·488·4688

SINCE 1951

U.S. CIGAR

SALES, INC.

CUSTOMER SERVICE AND DISTRIBUTION CENTER

6904 Parke East Boulevard
Tampa, Florida 33610

TO:

RING GAUGE

42

44

46

RING GAUGE

44

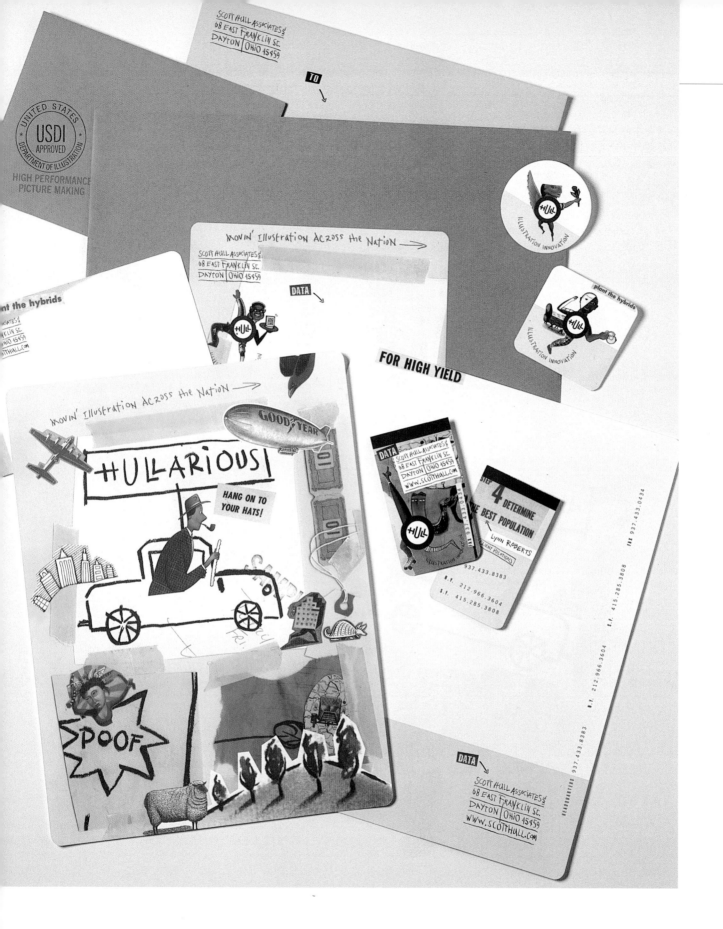

SIEBERT DESIGN FOR SCOTT HULL

CLIENT *Scott Hull Associates*
DESIGN *Siebert Design*
ART DIRECTOR *Lori Siebert*

This identity does literally what most do figuratively: it is a walking portfolio for illustrator Scott Hull. Earthy colors and a generous sprinkling of illustrations make it inviting and interesting. The handwritten logotype and tongue-in-cheek copy make it lots of fun to read.

HALAPPLE DESIGN FOR HALAPPLE DESIGN

CLIENT *Hal Apple Design & Communications, Inc.*
DESIGN *Hal Apple Design & Communications, Inc.*
ART DIRECTOR *Hal Apple*
DESIGNERS *Alan Otto, Jason Hasmi, Andrea Del Geurico, Hal Apple*

This work for Hal Apple Design reflects a balance of strategic, economic, and aesthetic thinking. Simplicity of design and print requirements facilitated the die-cut, which is a sly mnemonic reference to the principal's last name. A name no doubt co-opted by The Other Apple.

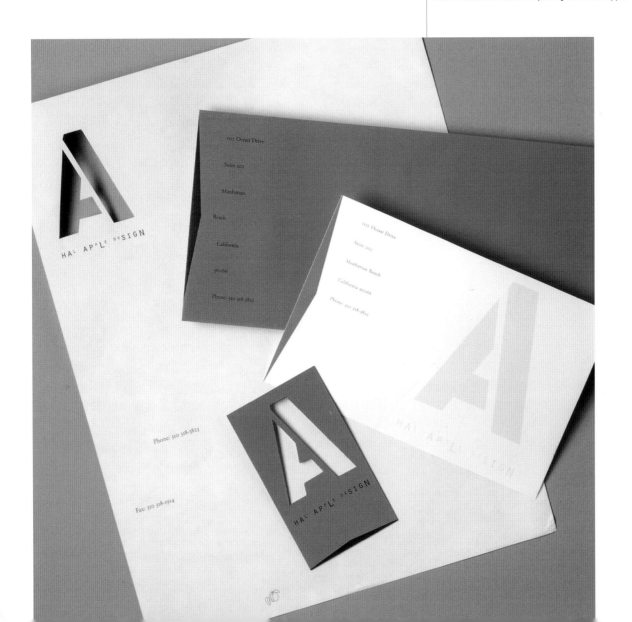

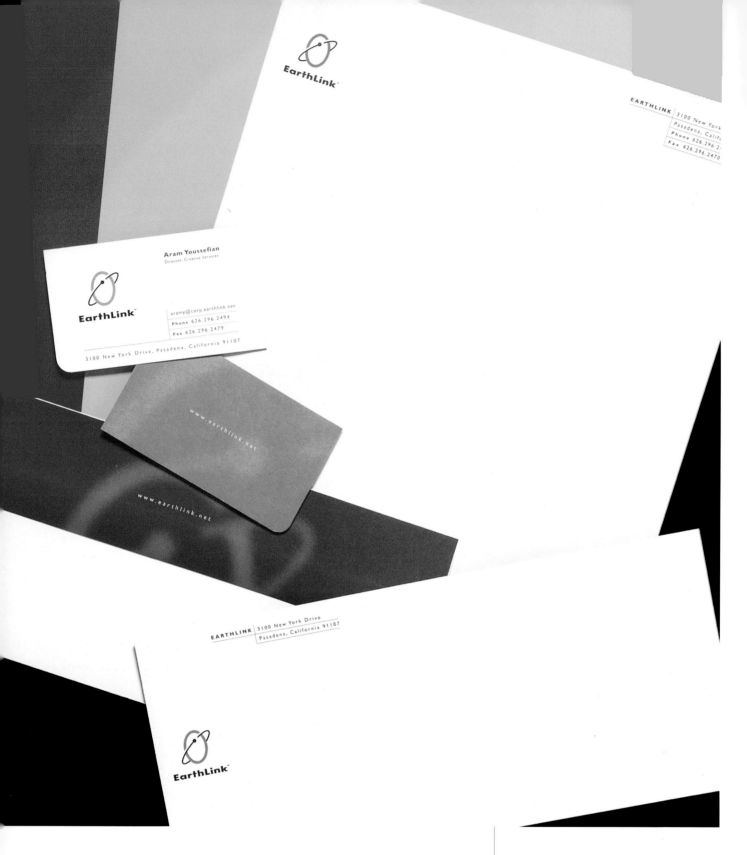

EARTHLINK CREATIVE SERVICES FOR EARTHLINK

CLIENT	*Earthlink Creative Services*
DESIGN	*Earthlink Creative Services*
ART DIRECTOR	*Aram Youssefian*
DESIGNER	*Barbara Chan*
ILLUSTRATOR	*Scott Hull Associates*

Playfulness within a corporate format isn't easy to achieve. Earthlink Creative Services did it by rounding the edges of its business card and stationery and backing each application with different, unexpected bright colors. The logo colors remain constant throughout.

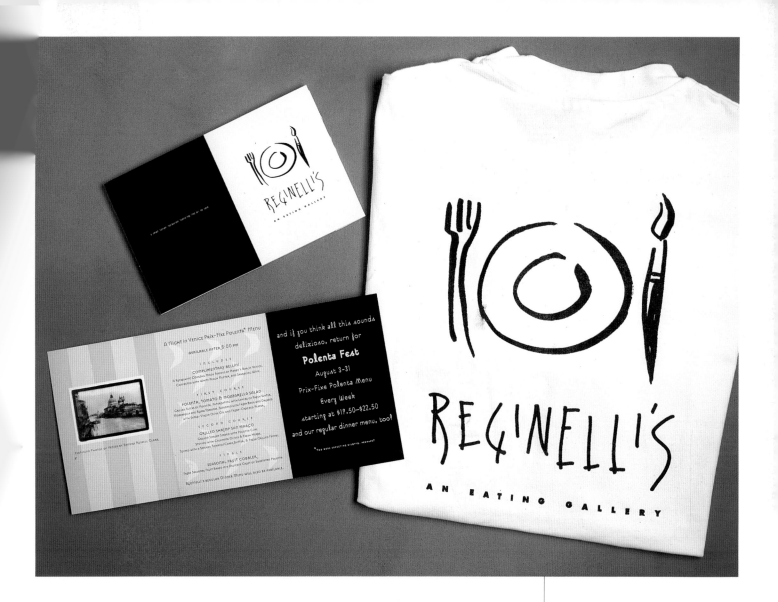

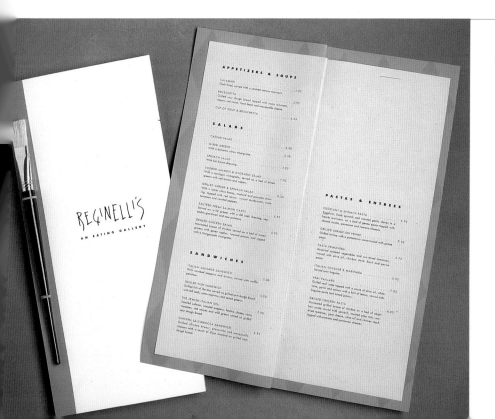

ZANDE NEWMAN DESIGN FOR REGINELLI'S

CLIENT	*Reginelli's/Darryl Reginelli, Stephanie Bruno*
DESIGN	*Zande Newman Design*
ILLUSTRATOR	*Robert Guthrie*
DESIGNERS	*Michelle Zande, Adam Newman*

This a lively, approachable execution for a place that sounds like great fun: an eating gallery. The spontaneous logo is perfectly appropriate as part of a descriptive mark. The character of the restaurant is further conveyed by the use of different paintbrushes for different menus.

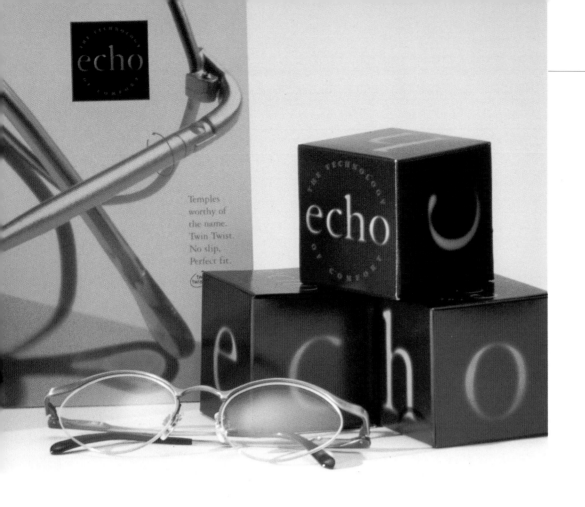

Temples
worthy of
the name.
Twin Twist.
No slip.
Perfect fit.

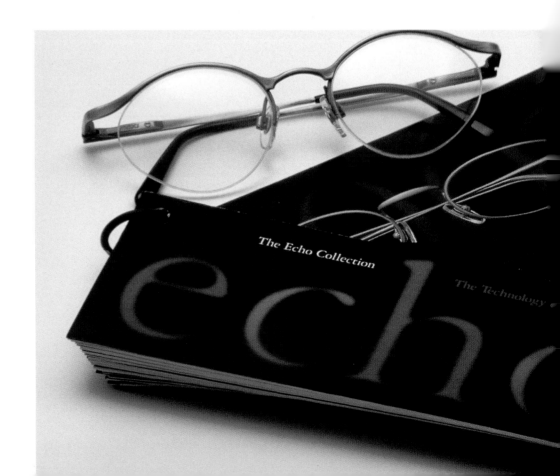

The Echo Collection

The Technology

CLIENT *Silhouette Optical*
DESIGN *Michael Gericke and Sharon Harel for Pentagram Design*

The name of a product often becomes the inspiration for
its identity, and with good reason. The more familiar
customers are with a name, the more likely it is the product
will succeed. Here, the name "echo" is suggested in
diffused typography that reverberates, or echoes, against a
dark background. Note how easily this particular identity
translates into packaging.

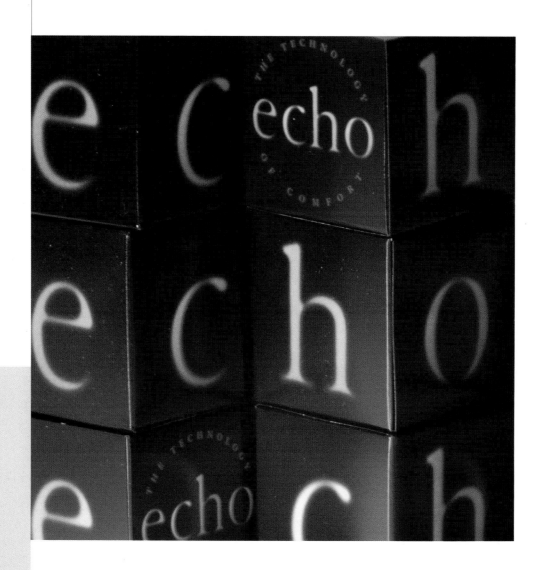

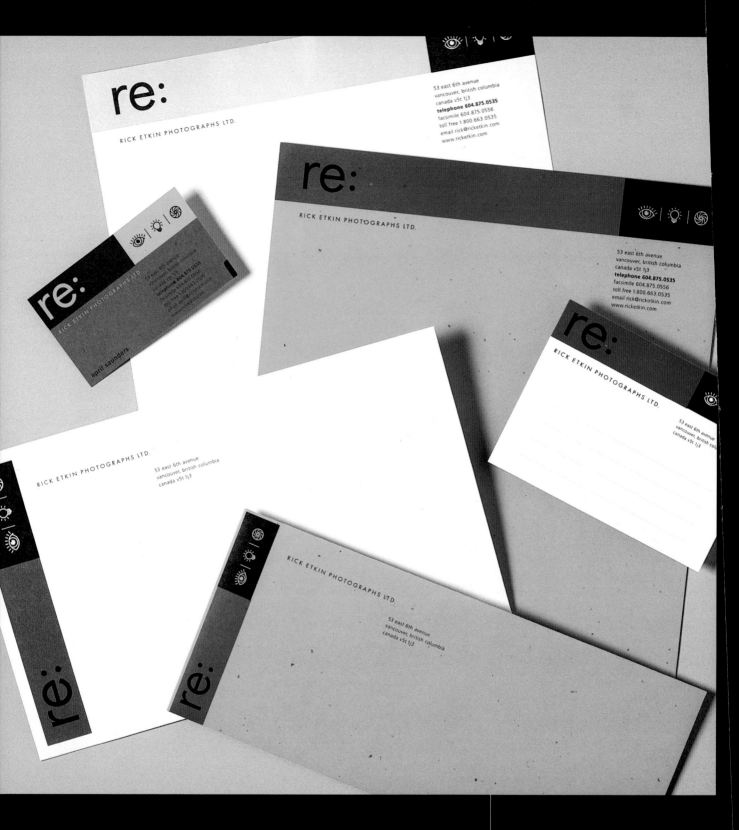

KARACTERS DESIGN GROUP FOR RICK ETKIN PHOTOGRAPHS

CLIENT	*Rick Etkin Photography*
DESIGN	*Karacters Design Group*
CREATIVE DIRECTOR	*Maria Kennedy*
DESIGNER	*Matthew Clark*

A play off his initials creates a visual shorthand that helps this photographer stand out. Website and promotional materials echo the 're:' device, linking it to positive emotions like re:solve. The limited color palette, which includes a black and white application, further enhances the identity.

DESIGN GUYS FOR DAYTON HUDSON'S SUNDANCE SHOP BAGS

CLIENT | Dayton Hudson Corporation
DESIGN | design guys
ART DIRECTOR | Steven Sikora
DESIGNERS | Richard Boynton, Steven Sikora

The logotype is simple, intelligent, and consistent throughout
elements from shopping bags to in-store signage. The colors and
photographic patterns, however, vary from piece to piece. What's
more, the photography is placed inside the bags. This yin and
yang of consistency and surprise creates great interest—and a
remarkably fresh identity.

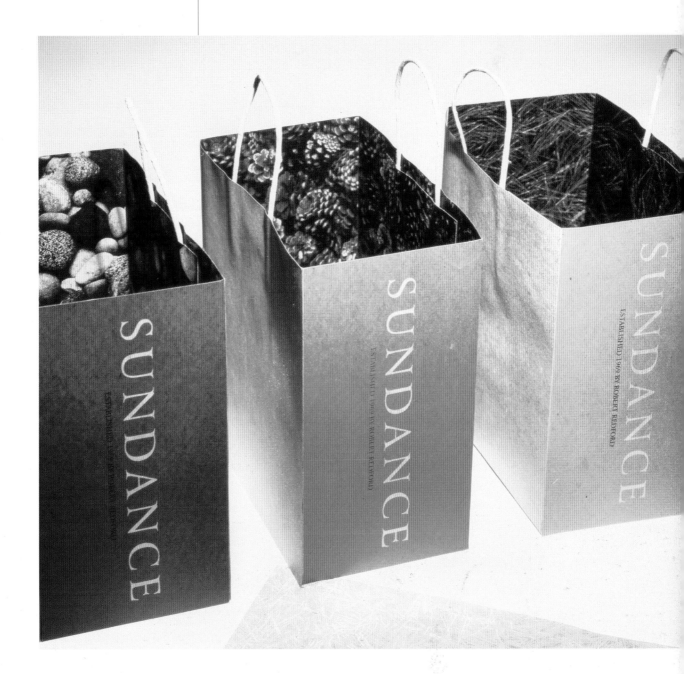

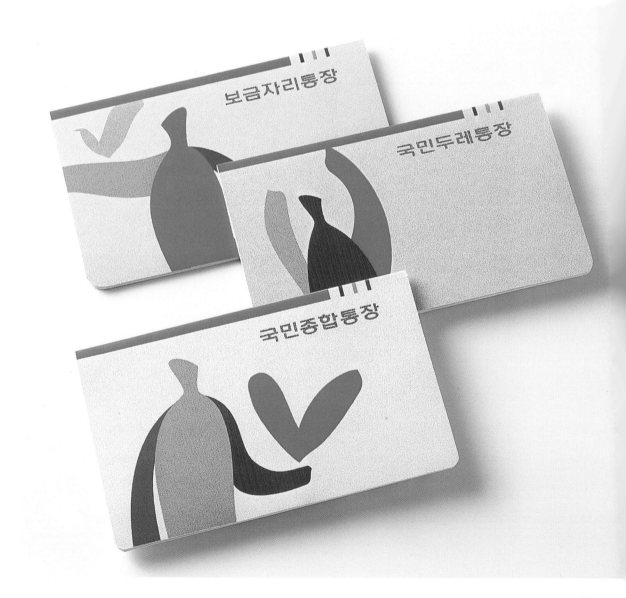

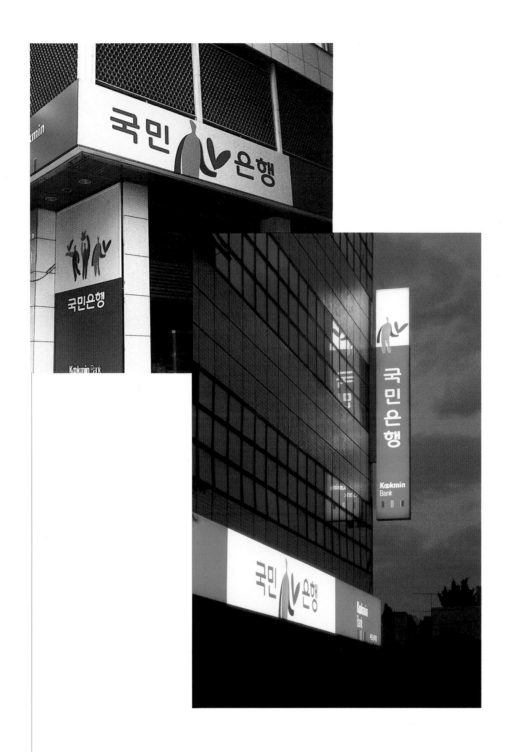

DESIGN PARK FOR KOOKMIN BANK

CLIENT	*Kookmin Bank*
DESIGN	*Design Park*
CREATIVE DIRECTOR	*Hyun Kim*
ART DIRECTOR	*Eenbo Sim*
DESIGNERS	*Keunmin Son, Young Chai, Yongkyu Chun, Hankyung Chung*

This is a classic example of using identity to reposition a brand. The name "Kookmin" literally means "nation people." Design Park's solution uses friendly corporate caricatures to emphasize the bank's new focus on people. The lively color palette of primary colors also helps to signal renewed vitality and growth.

STRATEGIC CHANGE MANAGEMENT

STRATEGIC CHANGE MANAGEMENT

SCOTT JACOBSON

4329 E. McDONALD PHOENIX, AZ 85018
PH 602 840-6509 FAX 602 840-7501
ScottJ01@aol.com

4329 E. McDONALD PHOENIX, AZ 85018 PH 602 840-6509 FAX 602 840-7501

AFTER HOURS CREATIVE FOR STRATEGIC CHANGE MANAGEMENT

CLIENT	*Strategic Change Management*
DESIGN	*After Hours Creative*
ART DIRECTOR	*After Hours Creative*
DESIGNER	*After Hours Creative*

Instead of using a logo, this work for Strategic Change
Management makes smart, tasteful use of a beloved cultural
icon. This identity rewards a second look with a smile. Any
company that can do this will be able to leap tall competitors
in a single bound.

DOGSTAR DESIGN FOR ROARING TIGER FILMS

CLIENT | *Roaring Tiger Films*
DESIGN | *DogStar Design*
ART DIRECTOR | *Jennifer Martin*
DESIGNER | *Jennifer Martin*
ILLUSTRATOR | *Rodney Davidson*

Commercial production is highly competitive—especially in California. The challenge is to distinguish yourself from the pack. This identity conveys Roaring Tiger's character with a fun, illustrative logo and tactile materials. Note the die-cut 'hole reinforcement' on each application.

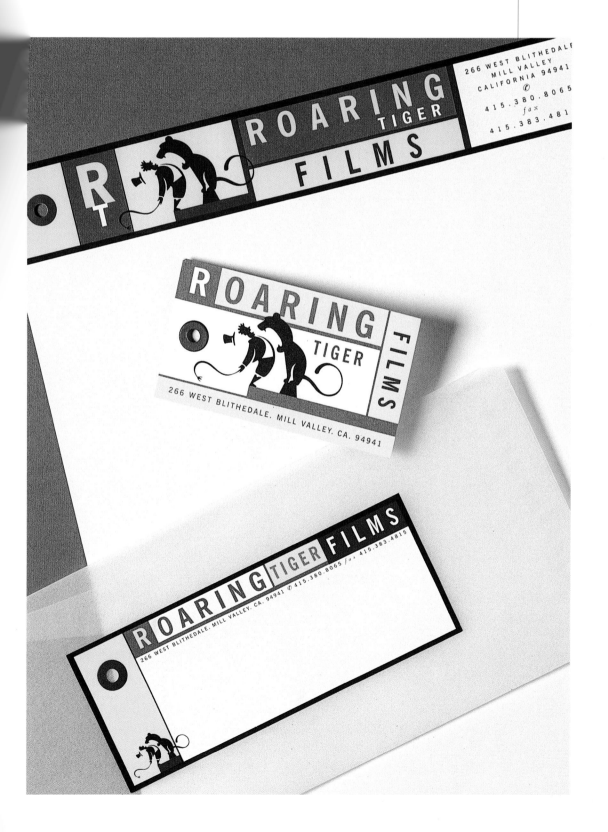

SAGMEISTER FOR RANDOM BUS

CLIENT *Random Bus*
DESIGN *Sagmeister Inc.*
ART DIRECTOR *Stefan Sagmeister*
ILLUSTRATOR *Eric Zim*
DESIGNER *Eric Zim*
PHOTOGRAPHER *Tom Schierlitz*

The photographic image of the bus varies from piece to
piece within this Sagmeister identity for music studio
Random Bus. The name "Random Bus" refers to tracks on
a mixing console. Interpreting it with a speeding toy bus
gives the company an appropriate sense of camp.

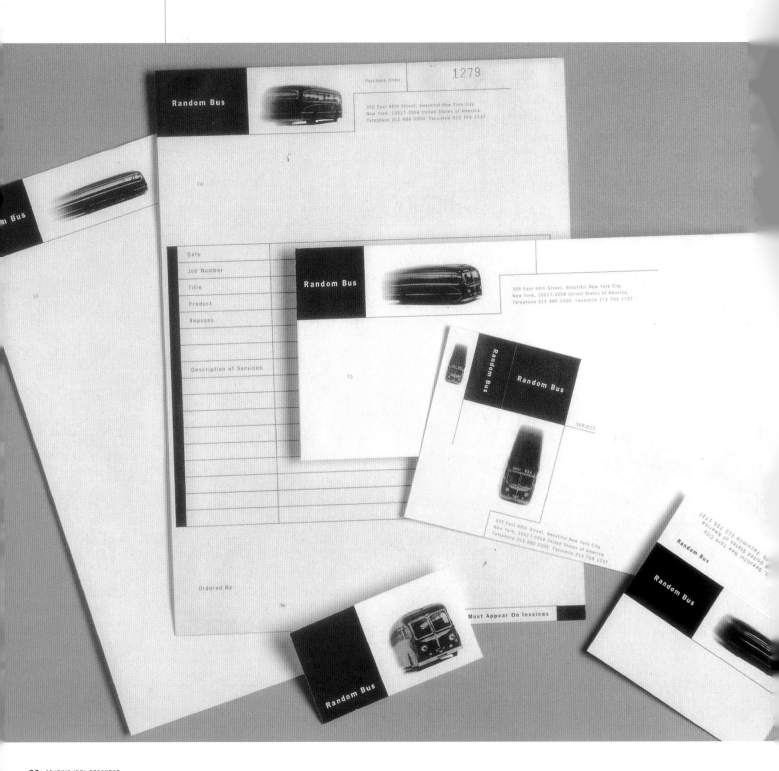

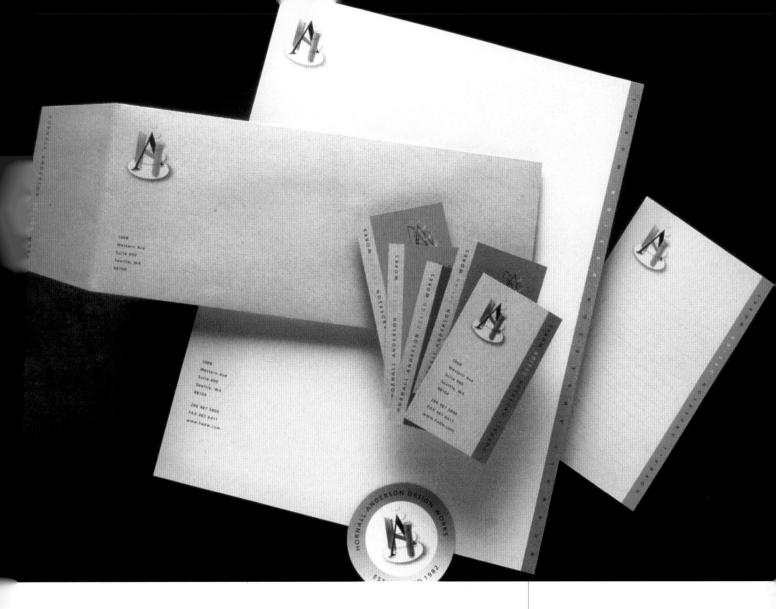

HORNALL ANDERSON DESIGN WORKS FOR HORNALL ANDERSON DESIGN

CLIENT	*Hornall Anderson Design Works, Inc.*
DESIGN	*Hornall Anderson Design Works, Inc.*
ART DIRECTOR	*Jack Anderson*
ILLUSTRATOR	*David Bates*
DESIGNERS	*Jack Anderson, David Bates*

Hornall Anderson again, this time designing an identity for themselves. Color schemes vary from application to application and color itself is used in surprising ways. Note the intensity of color on the envelope flap. Consistent logo placement and use of typography keep the identity cohesive.

йцукенгшшзхъфывапролджэячсмить

ПРОЛДЖЭЯЧ

MENY

PRAVDA

MATTEO BOLOGNA DESIGN FOR PRAVDA BAR

CLIENT *Pravda*
DESIGN *Matteo Bologna for Matteo Bologna Design NY*

Pravda is a Russian bar in New York City. This logotype, its highly structured applications, and its red color palette are reminiscent of both the WPA and Russian Constructivism. (A style characterized by very vertical/horizontal or diagonal axis orientations.) The designers created the font family Pravda to articulate the bar's style and character.

"ЧТО У ТРЕЗВОГО НА
УМЕ, ТО У ПЬЯНОГО
НА ЯЗЫКЕ"
– народная мудрость

PꓤAVᗡA

281 LAFAYETTE STREET NEW YORK NY 10012 PHONE: 212-226 4696 FAX 212-226 5052

PꓤAVᗡA

281 LAFAYETTE ST. NEW YORK NY 10012

PꓤAVᗡA

281 LAFAYETTE ST. NEW YORK NY 10012

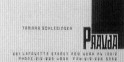

TAMARA SCHLESINGER

281 LAFAYETTE STREET NEW YORK NY 10012
PHONE 212-226 4696 FAX 212-226 5052

ANA OPITZ

281 LAFAYETTE STREET NEW YORK NY 10012
PHONE 212-226 4696 FAX 212-226 5052

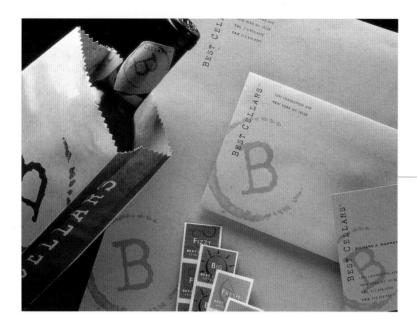

HORNALL ANDERSON DESIGN WORKS FOR BEST CELLARS

CLIENT	*Best Cellars*
DESIGN	*Hornall Anderson Design Works, Inc.*
ART DIRECTOR	*Jack Anderson*
DESIGNERS	*Jack Anderson, Lisa Cerveny, Jana Wilson*

This identity works on many levels—not least of which is its foundation: a descriptive mark built around a literal wine stain. The logo is simple, but quite versatile. It works as well in the letterhead system as it does in consumer brochures and on dusty bottles of red wine.

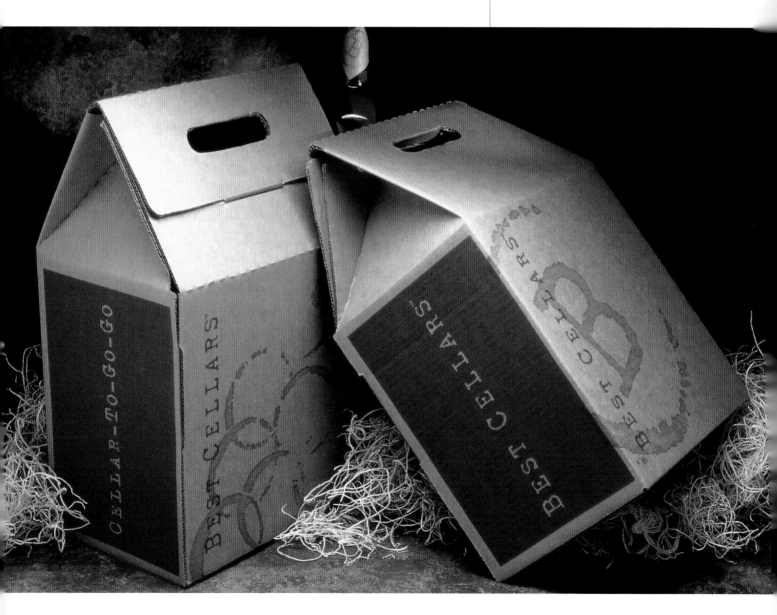

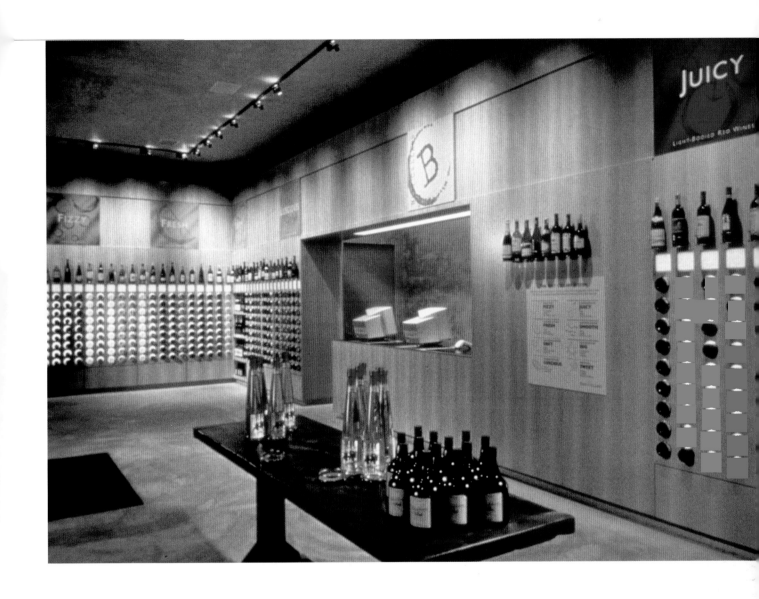

A E R I A L
FIFTY-EIGHT FEDERAL
SAN FRANCISCO 94107
415 957 9761 F 415 957 9739

AERIAL DESIGN FOR AERIAL DESIGN

CLIENT *Aerial Computer Productions, Inc.*
DESIGN *Aerial Computer Productions, Inc.*
ART DIRECTOR *Tracy Moon*
DESIGNER *Tracy Moon*
PHOTOGRAPHER *R. J. Muna*

The litmus test of a good identity is often its "ownability." This system by and for Aerial is something no other design firm could use. Even the typography supports the open, airy concept. There's whimsy in the old-fashioned clothespins, but the stylish photographic treatment keeps the work contemporary.

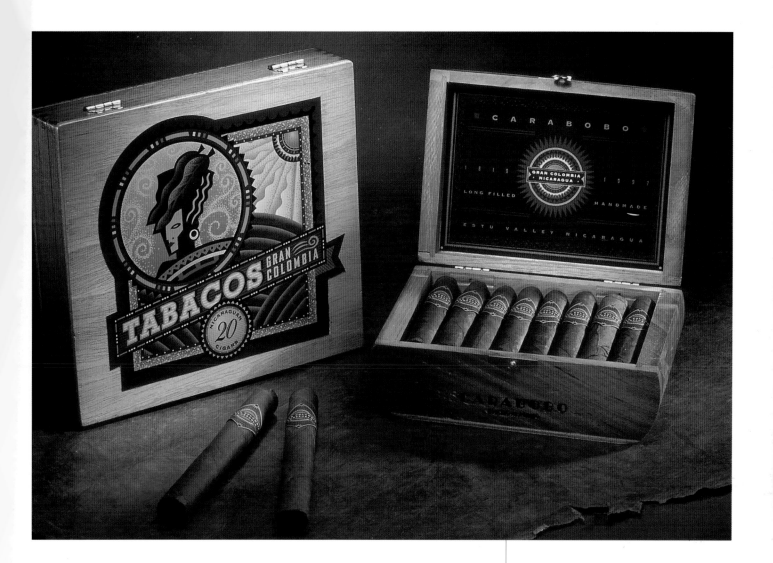

GRETEMAN GROUP FOR TABACOS GRAN COLOMBIA

CLIENT *Tobacos Gran Colombia*
DESIGN *Greteman Group*
ART DIRECTOR *Sonia Greteman*
DESIGNERS *Sonia Greteman, James Strange*

The heart of this South American inspired identity is a classic typographic mark. On the cigars, the company's name is housed in an organic seal that echoes the rays of the sun. On the box, the seal is reprised with a beautiful, powerful woman at its heart. This contemporary twist gives the identity greater appeal.

STUDIO HILL FOR STUDIO HILL

CLIENT	*Studio Hill*
DESIGN	*Studio Hill*
ART DIRECTOR	*Sandy Hill*
DESIGNERS	*Sandy Hill, Alan Shimato*

The idea's in the name, some designers say. In this
example, Studio Hill makes a mountain out of theirs with
an integral, die-cut "hill" logo at the bottom of each
application. The color palette also mirrors the character of
the studio's New Mexico home.

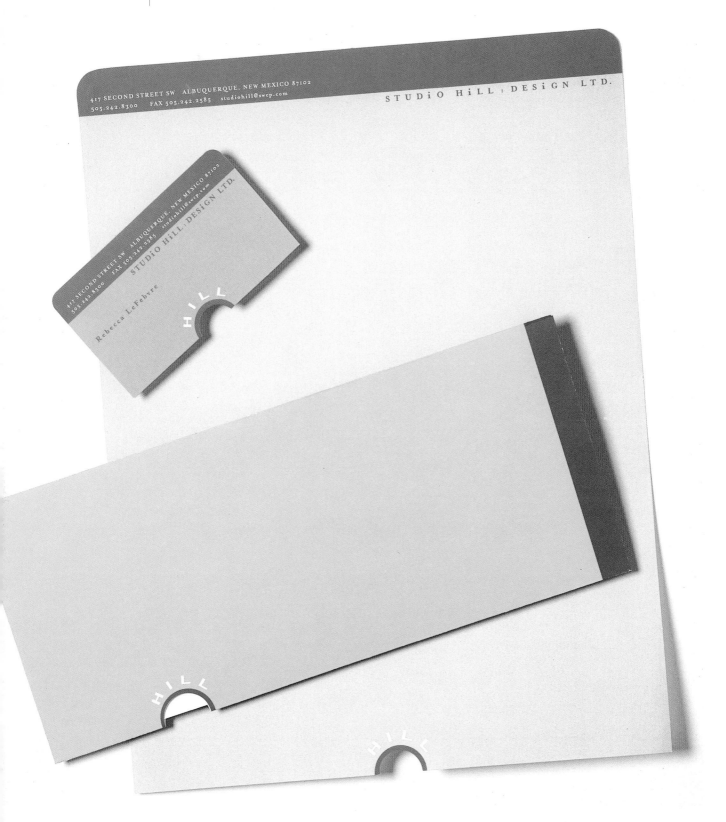

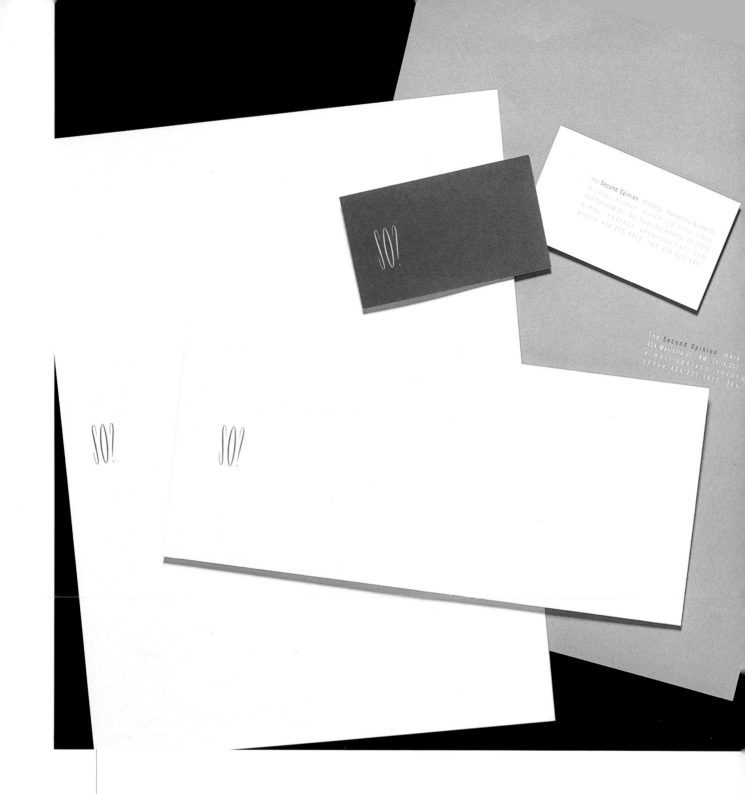

AFTER HOURS CREATIVE FOR SECOND OPINION

CLIENT	*Second Opinion*
DESIGN	*After Hours Creative*
ART DIRECTOR	*After Hours Creative*
DESIGNER	*After Hours Creative*

The client's acronym poses a haunting question for any
company or person hoping to bring The-Next-Big-Thing
to market. So? Who cares? After Hours Creative turns that
acronym/question into a smart, sophisticated logotype
with a color palette that keeps it corporate.

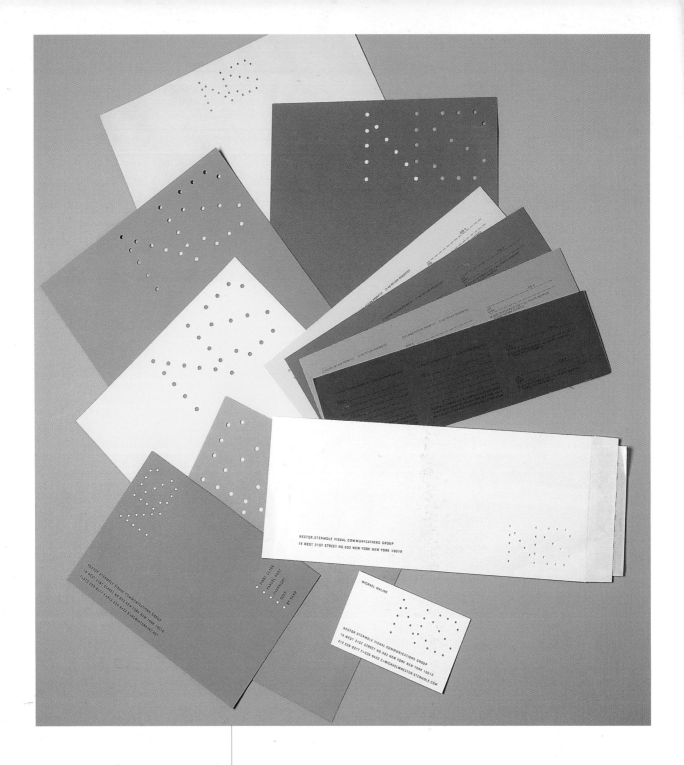

NESTOR STERMOLE FOR NESTOR STERMOLE

CLIENT	*Nestor Stermole*
DESIGN	*Nestor Stermole*
ART DIRECTORS	*Okey Nestor, Rick Stermole*
DESIGNER	*Robert Wirth*

Simple mnemonic letterforms, brilliant colors, and a punched-hole motif combine to help this identity system make a vivid impression. The punched holes are both tactile and visual; they allow color to show through from behind. Execution is consistent across every application— from presentation folders to the front door.

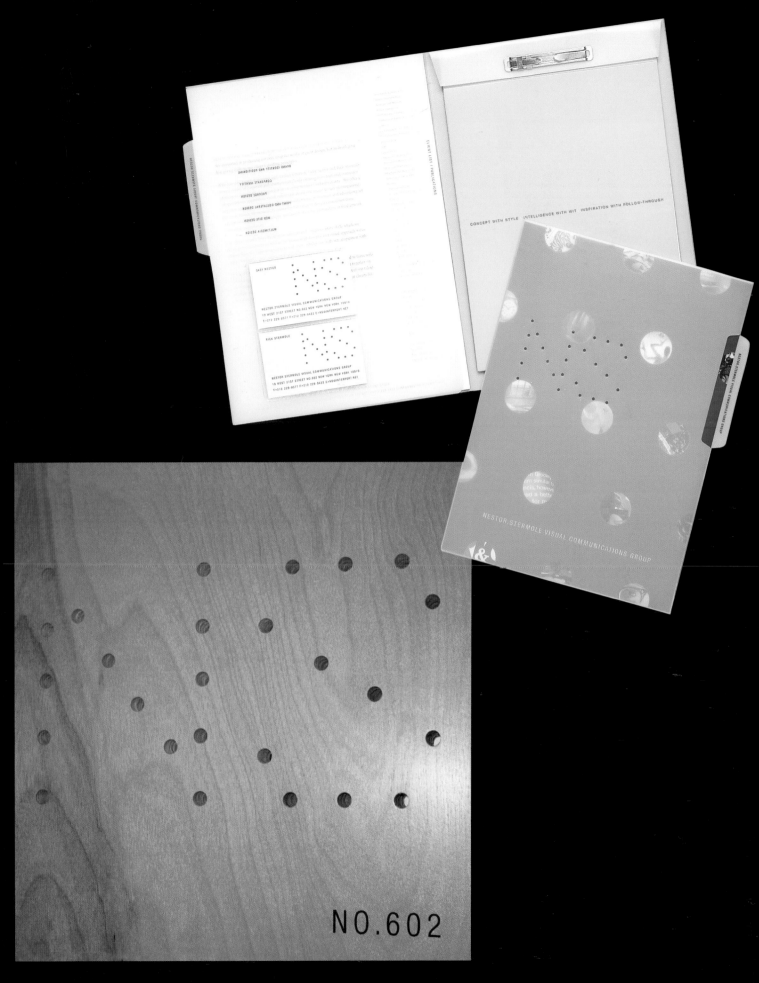

NO.602

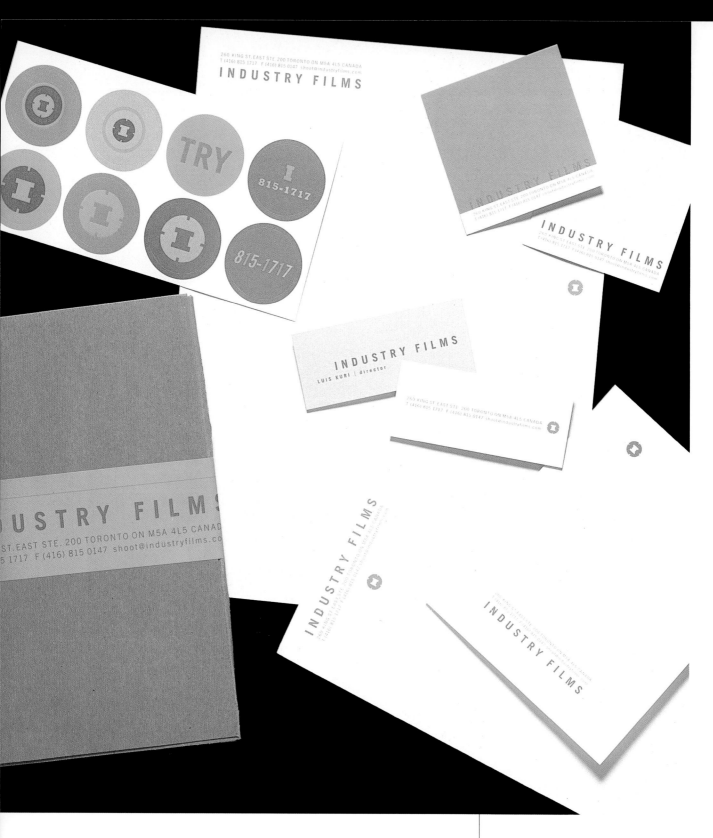

BLOK DESIGN FOR INDUSTRY FILMS

CLIENT | *Industry Films*
DESIGN | *Blok Design*
ART DIRECTOR | *Vanessa Eckstein*
DESIGNER | *Vanessa Eckstein*

Another identity with a slight constructivist feel to it. Here, a simple logotype partnered with a symbol hammers home the client's primary initial. The logotype and symbol change configurations on different applications to create visual interest. The color palette and supporting typography add consistency.

CATHERINE ZASK FOR COLLEGE INTERNATIONAL DE PHILOSOPHIE

CLIENT | *Collège International de Philosophie*
DESIGN | *Catherine Zask*
ART DIRECTOR | *Catherine Zask*
DESIGNER | *Catherine Zask*

Clean, clear, refined, and very logical. This identity system perfectly reflects the character of a college of philosophy. The stationery package is kept to a cool, contemporary white. The booklet system is rendered in harmonious colors. A pattern of vertical hairlines adds interest to the logotype.

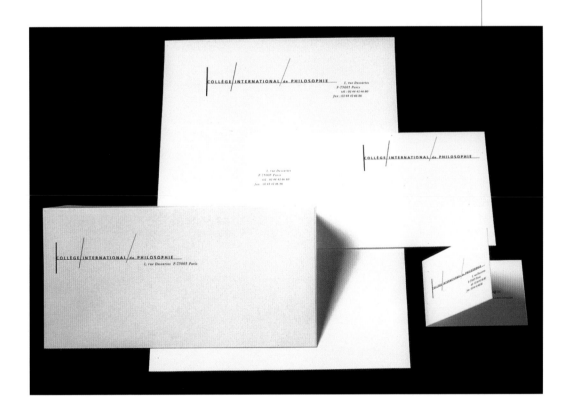

VISUAL DIALOGUE FOR KENT DAYTON PHOTOGRAPHY

CLIENT | *Kent Dayton Photography*
DESIGN | *Visual Dialogue*
ART DIRECTOR | *Fritz Klaetke*
DESIGNER | *Fritz Klaetke*
PHOTOGRAPHER | *Kent Dayton*

Large and generous use of the photographer's work forms a
consistent visual backdrop for this system. Even the back
of the stationery is used as a literal billboard. The clean
typography and its placement create interest, but don't
overshadow the work or the message.

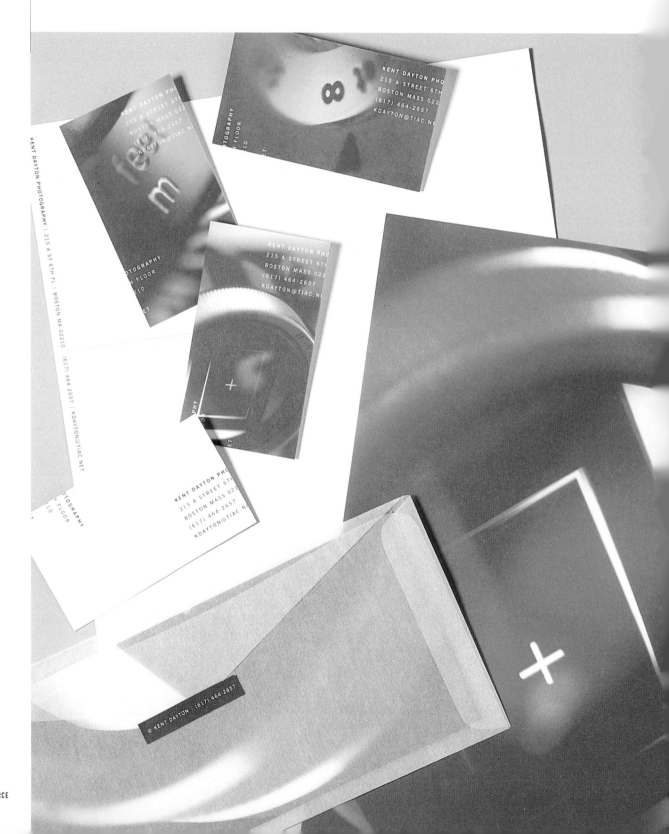

VANDERBYL DESIGN FOR ROCKETSCIENCE

CLIENT · *rocketscience*
DESIGN · *Vanderbyl Design*
ART DIRECTOR · *Michael Vanderbyl*
DESIGNERS · *Michael Vanderbyl, Amanda Fisher*

This is a sophisticated, understated approach to an identity that could easily have included garish colors and exploding rockets. The illustrative logo is humorous, handled in an almost encyclopedic style. The color palette and typography choices are all crafted to connote intelligence and credibility.

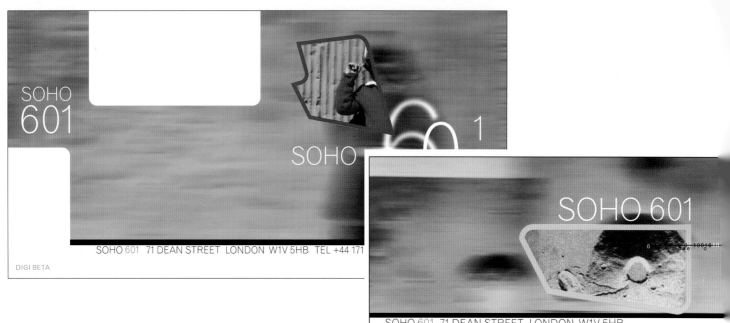

SOHO
601

DIGI BETA

SOHO 601 71 DEAN STREET LONDON W1V 5HB TEL +44 171

SOHO 601

SOHO 601 71 DEAN STREET LONDON W1V 5HB
TEL +44 171 439 2730 FAX +44 171 734 3331 WEB www.sohogroup.com

[MANAGING DIRECTOR]

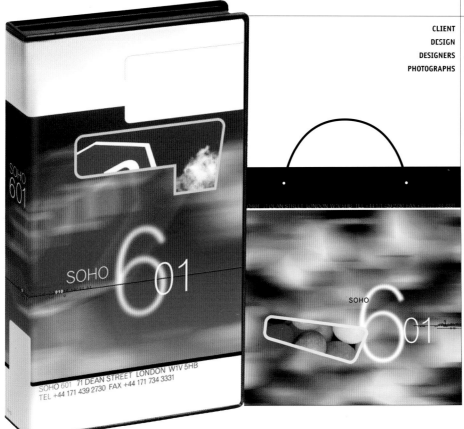

WHY NOT ASSOCIATES FOR SOHO 601

CLIENT	*Soho 601*
DESIGN	*Why Not Associates*
DESIGNERS	*Andy Altmann, Davis Ellis, Patrick Morrissey, Iain Cadby*
PHOTOGRAPHS	*PhotoDisc, Inc.*

A simplified type solution for the logo allows other strategic
elements to make important contributions to this identity.
Note that each application features different photography. In
this identity, the manipulated photography functions as a
visual sound bite demonstrating a range of the client's work:
digital post-production.

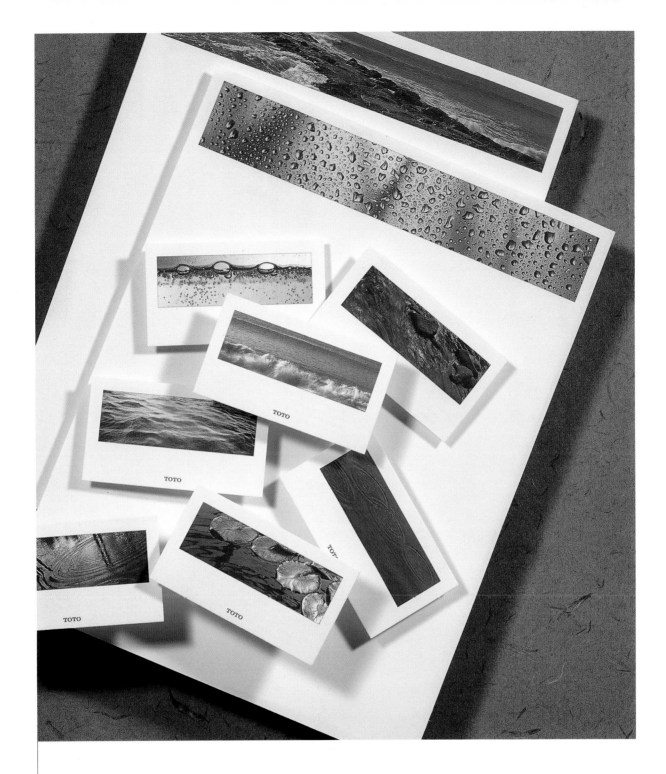

SAGMEISTER FOR TOTO NEW CONCEPT GROUP

CLIENT	*Toto New Concept Group*
DESIGN	*Sagmeister Inc.*
ART DIRECTOR	*Stefan Sagmeister*
DESIGNERS	*Stefan Sagmeister, Veronica Oh*
PHOTOGRAPHER	*Michael Grimm, Stock*
COPYWRITER	*Alfred Polzcyk, Ayse Birsel, Joan Capelin*

The use of ethereal photographic images of water is an ingenious and tasteful solution for a company that manufactures sophisticated toilets. This obvious appreciation of design positions the brand as unique in its industry. The business card back (not shown) carries contact information, but the word "toilet" is never used. Risky, but effective.

MORLA DESIGN FOR THE DISCOVERY CHANNEL SHOPPING BAGS

CLIENT *The Discovery Channel Store*
DESIGN *Morla Design*
DESIGNER *Jennifer Morla*
PHOTOGRAPHERS *Jennifer Morla, Angela Williams, Yoram Wolberger*

This identity is a perfect blend of art and science. The translucent materials and the delicate Helvetica typeface are simple and beautiful. The globe icon is echoed on the packaging in a Mercator-like computer-generated rendering of a sphere on a flat surface. Each application carries the same elements, creating consistency and harmony.

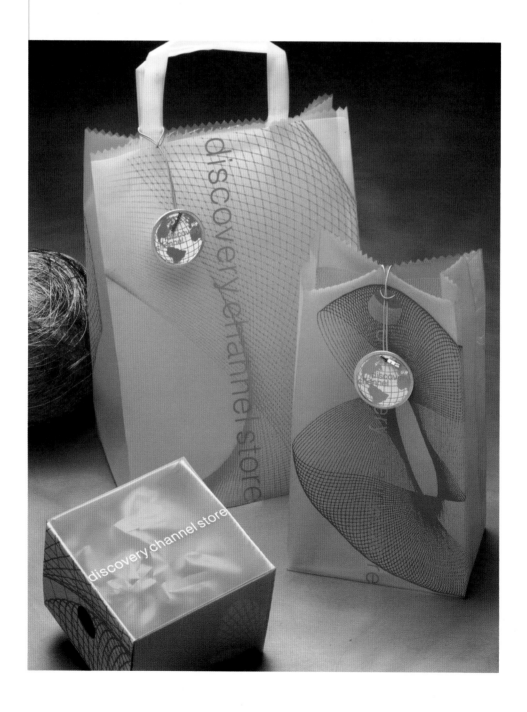

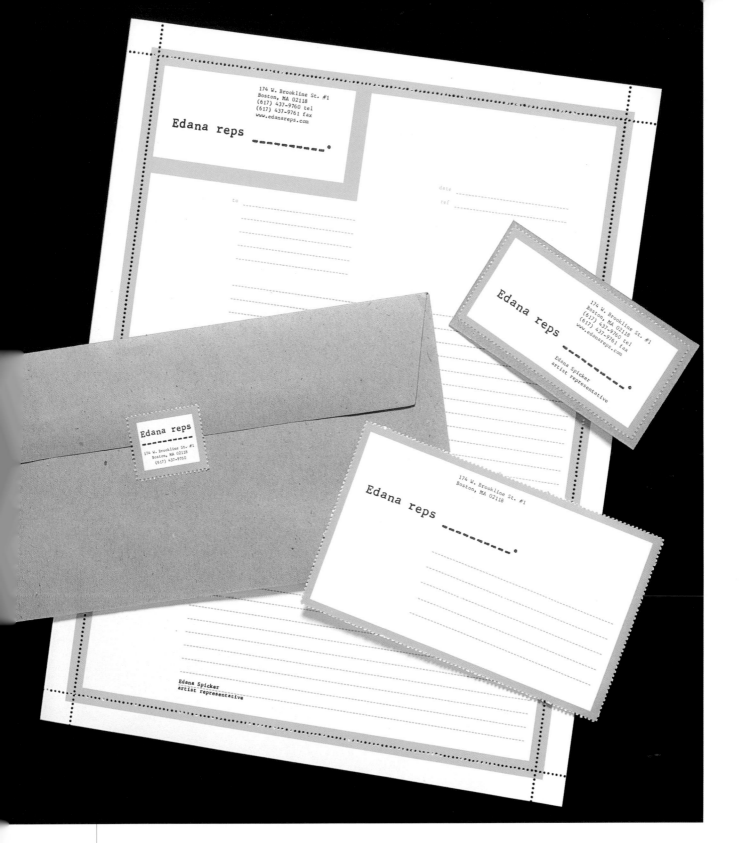

VISUAL DIALOGUE FOR EDANA REPS

CLIENT | *Edana Reps*
DESIGN | *Visual Dialogue*
ART DIRECTOR | *Fritz Klaetke*
DESIGNER | *Fritz Klaetke*

Typewriter fonts and perforated edges on almost all applications give this identity its distinctive "stamp book" look. The dashed fill-in-the-blank line on the business card, label, and letterhead allow Edana to customize mailings in a humorous way. Web site and promotional materials follow the branding lead set by this work.

SAGMEISTER FOR SCHERTLER AUDIO TRANSDUCERS

CLIENT	Schertler Audio Transducers
DESIGN	Sagmeister Inc.
ART DIRECTOR	Stefan Sagmeister
ILLUSTRATOR	Eric Zim
DESIGNERS	Stefan Sagmeister, Eric Zim
PHOTOGRAPHER	Tom Schierlitz
COPYWRITER	Stephan Schertler

Schertler manufactures high-end audio pick-ups. Their logo
(not shown) is created of concentric ellipses that evoke
the image of sound waves. The logotype here was created
from an existing font, with certain letters customized for
distinction. The black and white photographs are
sophisticated conceptual representations of the logo and,
ultimately, the company itself.

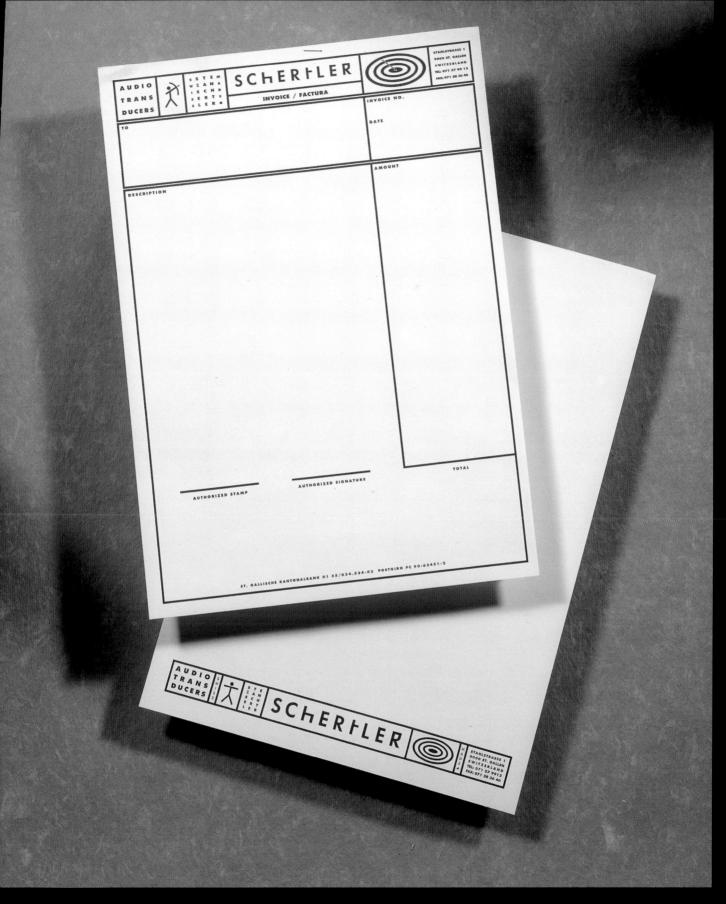

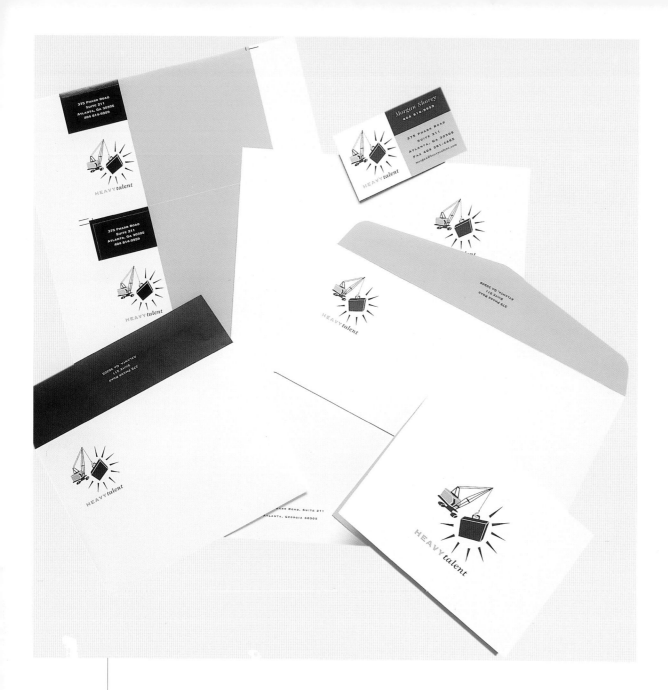

DOGSTAR FOR HEAVY TALENT

CLIENT	*Heavy Talent*
DESIGN	*DogStar*
DESIGNER	*Rodney Davidson*

DogStar's identity for this Atlanta artist and photographer's rep firm communicates instantly the business, the benefit, and the personality of Heavy Talent. The logo is illustrative and humorous; the typography supports it in both color and message focus. The business comes across as one that takes its work seriously—in a lighthearted way.

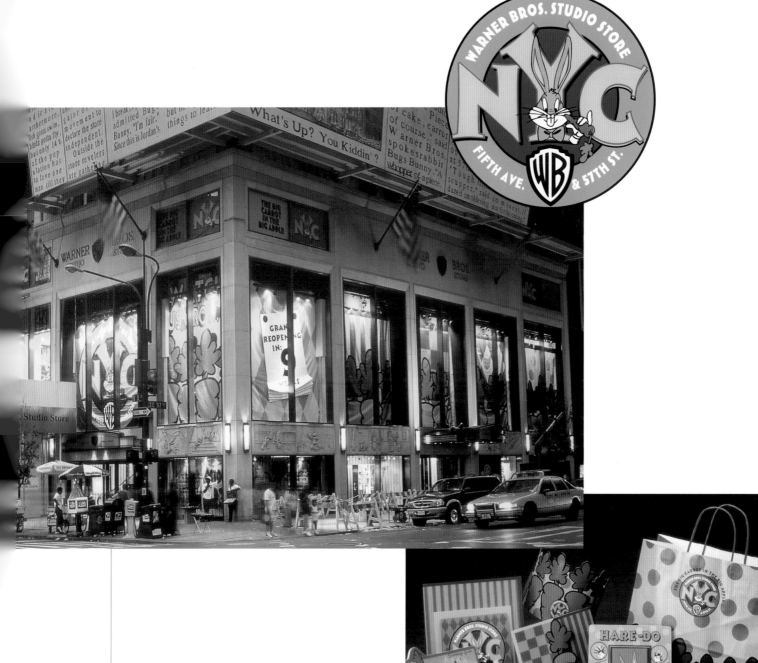

SMULLEN DESIGN FOR WARNER BROTHERS STUDIO STORE

CLIENT	*Warner Brothers Studio Store*
DESIGN	*Smullen Design*
CREATIVE DIRECTOR	*Maureen Smullen*
DESIGNERS	*Jill von Hartman, Maureen Smullen, Jennel Cruz*

It takes a lot to command attention on the streets of New York City. Smullen Design used giant carrots. The reopening of Warner Bros. Studio Store called for larger than life solutions built on the smallest illustrative details. This identity is rich in color, in shape, and in character(s).

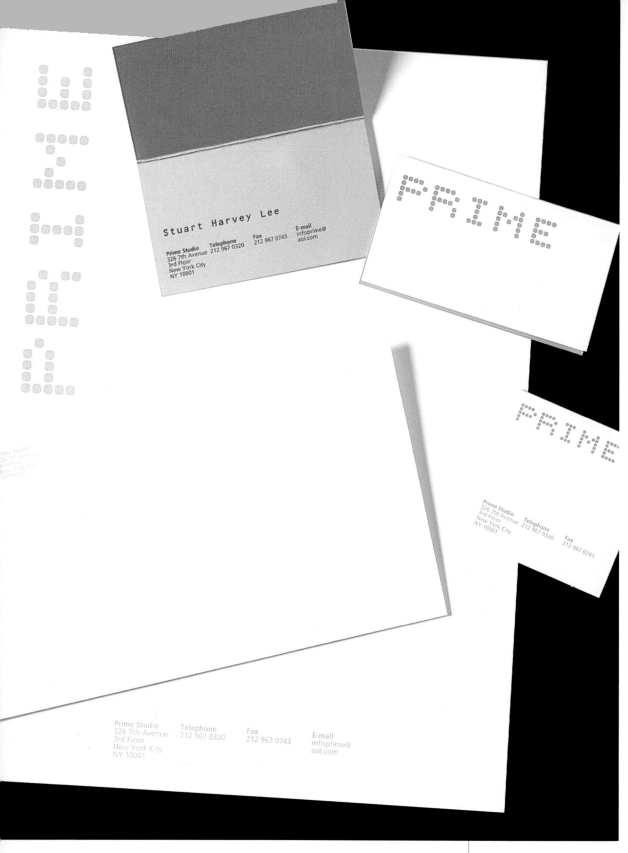

Stuart Harvey Lee

Prime Studio Telephone Fax E-mail
326 7th Avenue 212 967 0320 212 967 0743 infoprime@
3rd Floor aol.com
New York City
NY 10001

Prime Studio
326 7th Avenue Telephone
3rd Floor 212 967 0320 Fax
New York City 212 967 0743
NY 10001

Prime Studio Telephone Fax E-mail
326 7th Avenue - 212 967 0320 212 967 0743 infoprime@
3rd Floor aol.com
New York City
NY 10001

RUPERT BASSETT FOR PRIME STUDIO

CLIENT | Prime Studio
DESIGN | Prime Studio
ART DIRECTOR | Rupert Bassett, Stuart Harvey Lee
DESIGNER | Rupert Bassett

A minimalist gray and white palette and mechanized logo
are the elements Rupert Bassett chose to represent this
product design studio. This cool, elegant identity perfectly
integrates design and technology—literally what Prime
Studio must achieve in the course of its work.

KARACTERS DESIGN FOR BROADWAY PRINTERS

CLIENT | *Broadway Printers*
DESIGN | *Karacters Design Group*
DESIGNER | *Matthew Clark*

A simple letterform "b" is the foundation for this printer's identity. The "b" appears within different shapes, on different colors, and with different messages from application to application. The business cards, in fact, each make different funny points (wicked printing; good pricing, etc.). The consistency is in its attitude.

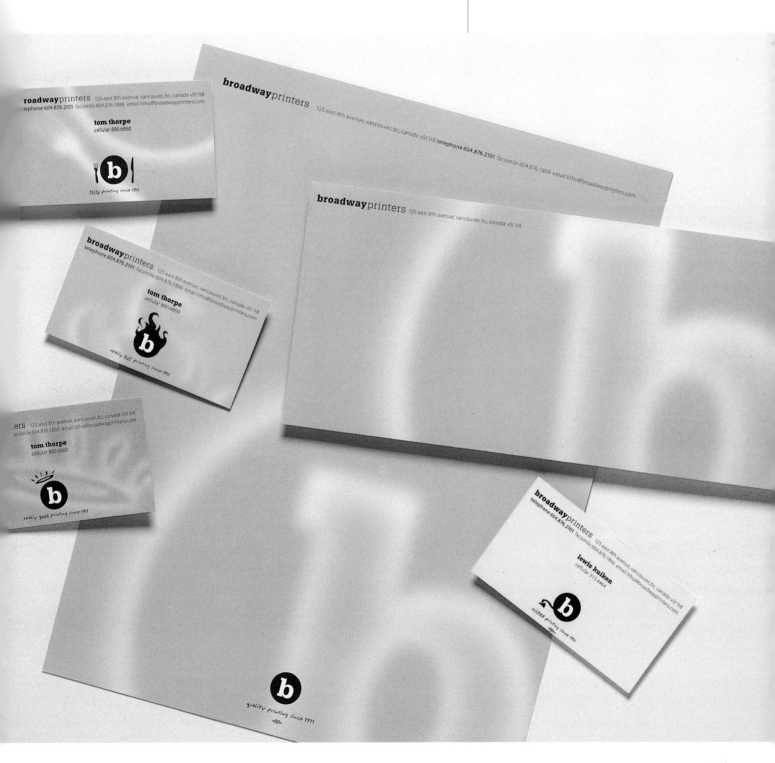

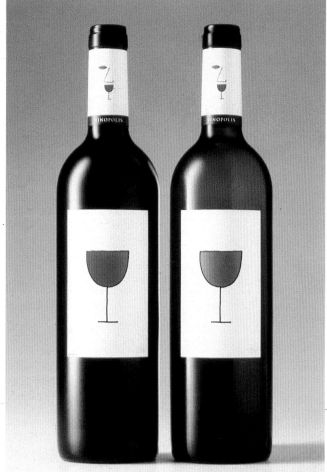

LEWIS MOBERLY FOR VINOPOLIS

CLIENT | *Vinopolis*
DESIGN | *Lewis Moberly*
ART DIRECTOR | *Mary Lewis*
ILLUSTRATOR | *Nin Glaister*
DESIGNERS | *Nin Glaister, Mary Lewis, Ann Marshall*

This intentionally childlike identity system is composed of simple, well-placed lines and colors. The strategic idea here is using the approachability of this work to represent the consumer-friendly nature of the company. The sophisticated simplicity of the graphic elements, however, leaves no doubt that this company knows its vintners.

VINOPOLIS
CITY OF WINE

MOTHER GRAPHIC DESIGN FOR GLOBE STUDIO

CLIENT *Globe Studio*
DESIGN *Mother Graphic Design*
ART DIRECTOR *Kristin Thieme*
DESIGNER *Kristin Thieme*

In this work by Mother Graphic, a custom-designed logo-type is used to build an identity system around a literal interpretation of the company name. Round business cards (a nice surprise) and rounded edges on stationery make the identity tactile, dimensional, and very distinctive.

CARRE NOIR FOR FRANCK ET FILS

CLIENT *Franck et Fils*
DESIGN *Carré Noir*
ART DIRECTOR *Béatrice Mariotti*
ILLUSTRATOR *Béatrice Mariotti*
DESIGNER *Béatrice Mariotti*

This rich, deep yellow is a brand statement in itself for the sophistication of Paris-based Frank et Fils. Carré Noir uses the logotype and its accompanying graphic elements in different sizes for different applications. Each speaks to a culture of refinement and elegance.

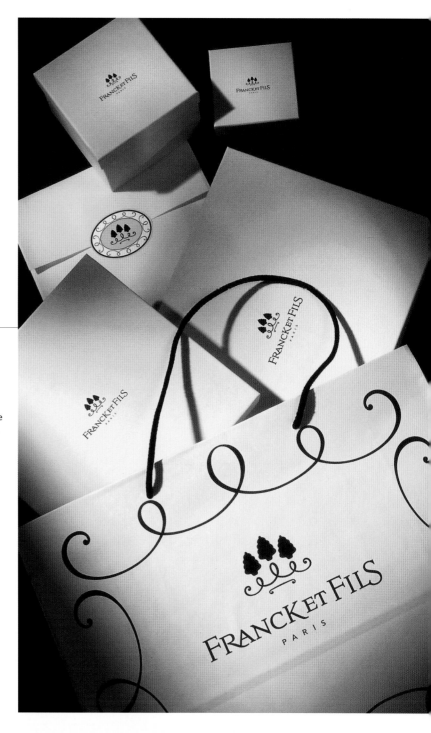

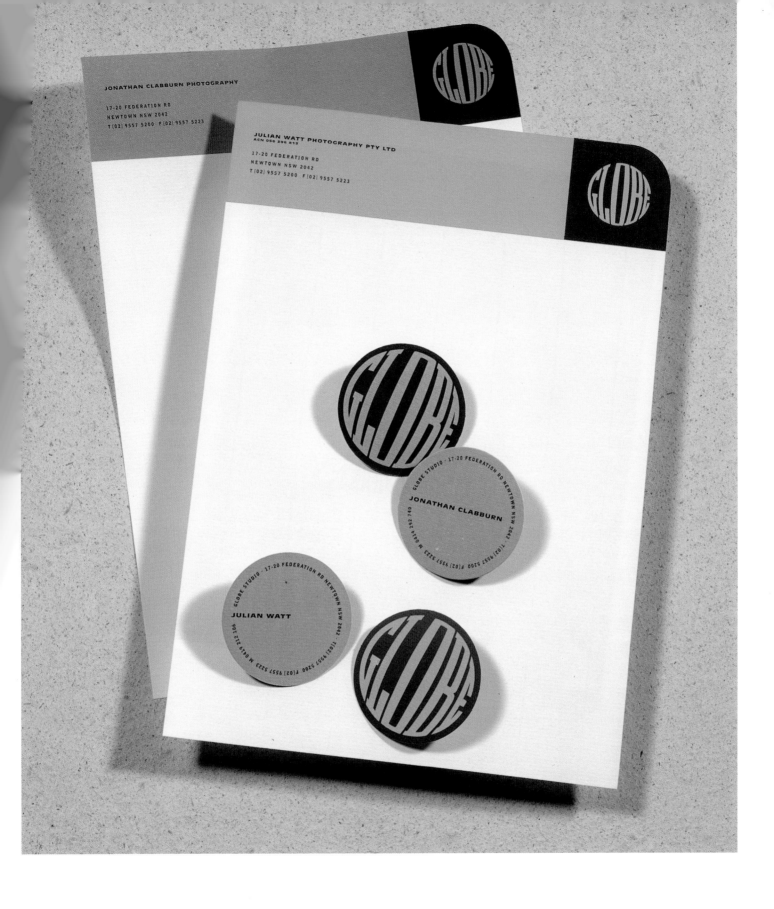

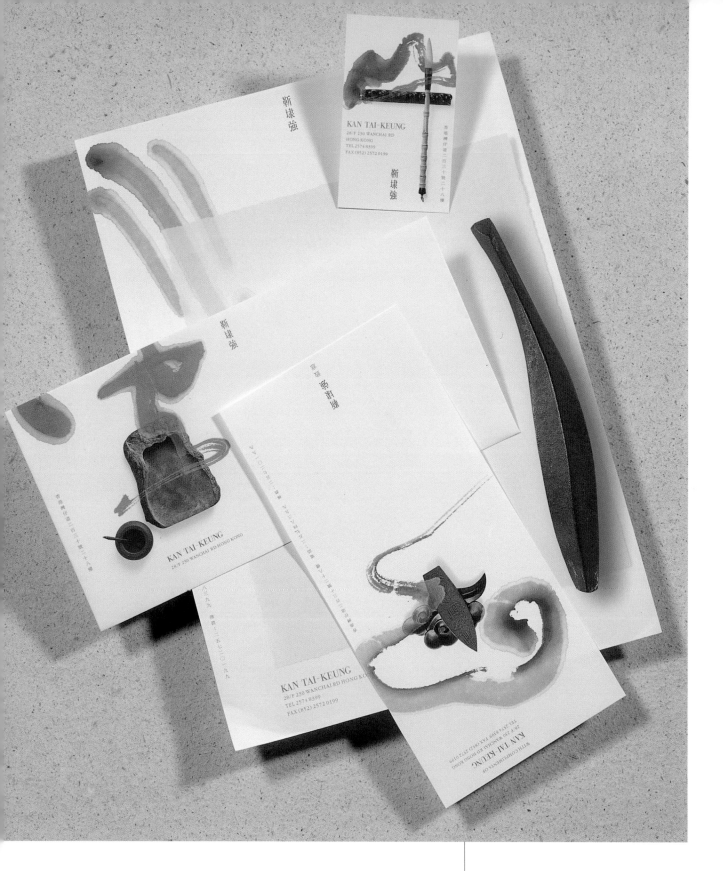

KAN & LAU DESIGN FOR KAN TAI-KEUNG

CLIENT *Kan Tai-keung*
DESIGN *Kan & Lau Design Consultants*
ART DIRECTOR *Kan Tai-keung*
DESIGNER *Kan Tai-keung*

Combining watercolor brushwork with photographic images of what seem to be ancient artist's tools makes a powerful statement in this personal identity system for designer Kan Tai-Keung. Each application is a work of art in itself. It's easy to imagine clients looking forward to communication—even billing—from Mr. Tai-Keung.

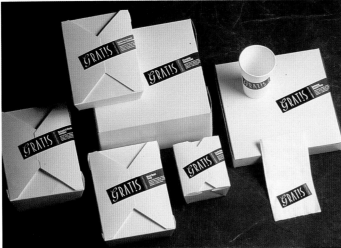

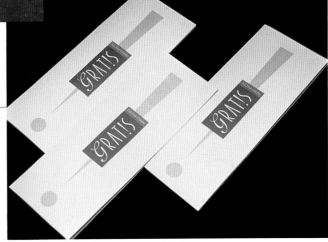

BRIGHT & ASSOCIATES FOR GRATIS

CLIENT	*Gratis Restaurant*
DESIGN	*Bright Strategic Design*
ART DIRECTORS	*Bill Corridori, Keith Bright*
ILLUSTRATOR	*Bill Corridori*
DESIGNER	*Bill Corridori*

The logo for this contemporary California restaurant offering a fat-free bill of fare is, appropriately enough, thin. It also serves to demonstrate the phonetics and the emphasis of the restaurant's name. The typeface was customized to echo and enhance the effect of the linear elements used in the restaurant's interior décor.

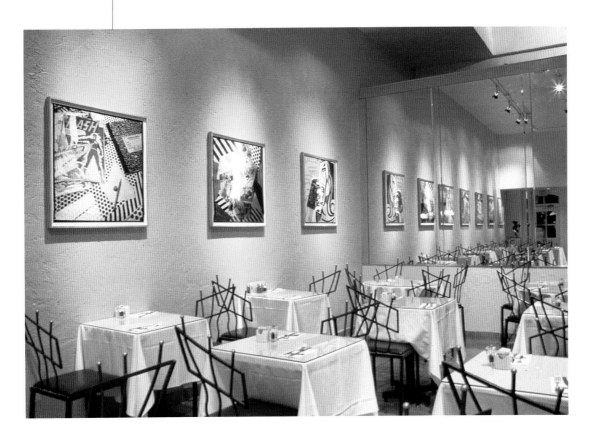

SAGMEISTER FOR DHA (USA)

CLIENT	*DHA (USA)*
DESIGN	*Sagmeister Inc.*
ART DIRECTOR	*Stefan Sagmeister*
DESIGNER	*Stefan Sagmeister*
PHOTOGRAPHER	*Tom Schierlitz*

Piece for piece, Sagmeister's identity system for DHA offers considerable impact for a relatively low-cost execution. The typography isn't typography at all; it's included in the photography on each application. How could any customer resist keeping this 'on-hand' business card on hand? That's the name of the game in identity.

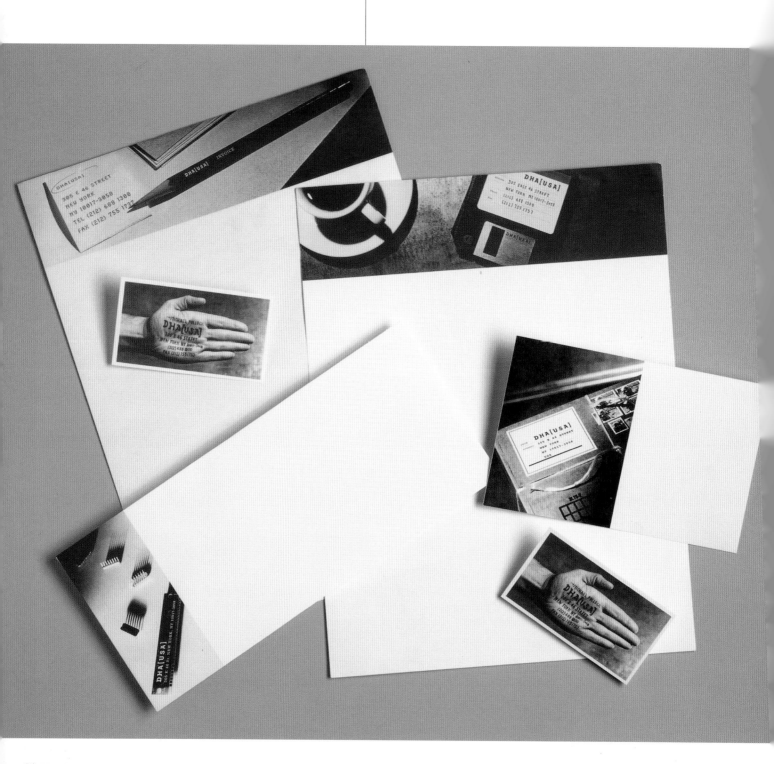

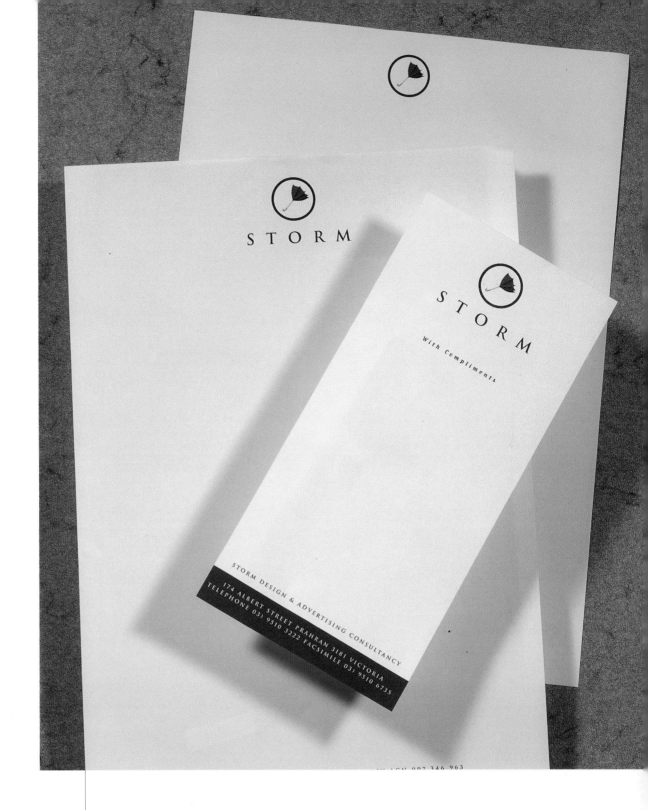

STORM DESIGN AND ADVERTISING CONSULTANCY FOR STORM

CLIENT	*Storm Design & Advertising Consultancy*
DESIGN	*Storm Design & Advertising Consultancy*
ART DIRECTORS	*David Ansett, Dean Butler, Julia Jarvis*
DESIGNERS	*David Ansett, Dean Butler, Julia Jarvis*
PHOTOGRAPHER	*Marcus Struzina*

This identity solution is deceptively simple. A visual pun on the company's name becomes an elegantly illustrated logo housed in a rich, creamy color palette. The freshness of the system is due at least in part to how unexpected an execution it is. It gives the company a distinct and utterly refreshing personality.

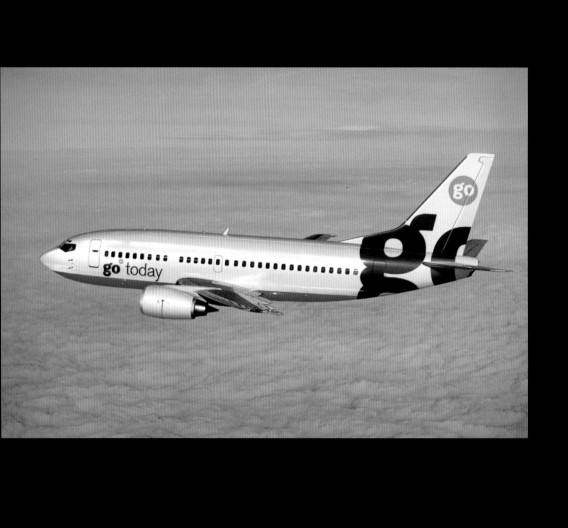

WOLFF OLINS FOR GO AIRLINES

CLIENT	Go Airlines
DESIGN	Wolff Olins
ART DIRECTOR	Doug Hamilton
DESIGNERS	Robbie Laughton, Adam Throup, Joseph Mitchell
PHOTOGRAPHER	Network Photographers

"Go" is a simple, direct, concise, and effective name for an airline. This logotype is equally spare. It is rendered in a friendly sans serif font made unique by different croppings on various applications. A wide color palette of elementary colors gives the system variety and spontaneity.

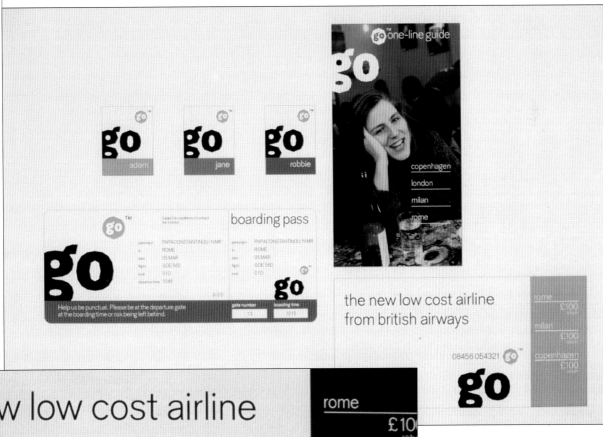

HORNALL ANDERSON FOR ALTA BEVERAGE CORP.

CLIENT | *Alta Beverage Company*
DESIGN | *Hornall Anderson Design Works, Inc.*
ART DIRECTOR | *Jack Anderson*
DESIGNERS | *Jack Anderson, Larry Anderson, Julie Keenan*

A custom-lettered logotype evoking cool mountain peaks immediately telegraphs the product focus of this beverage company. The dominant dark cobalt blue color, especially given its pairing with crisp white, is visually refreshing. That in itself is an appropriate signal for the beverage industry.

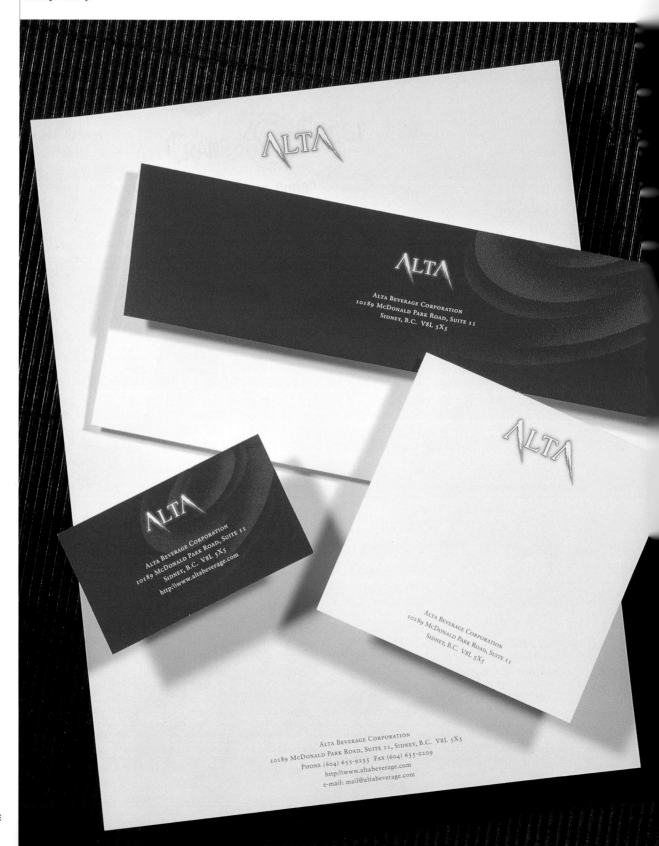

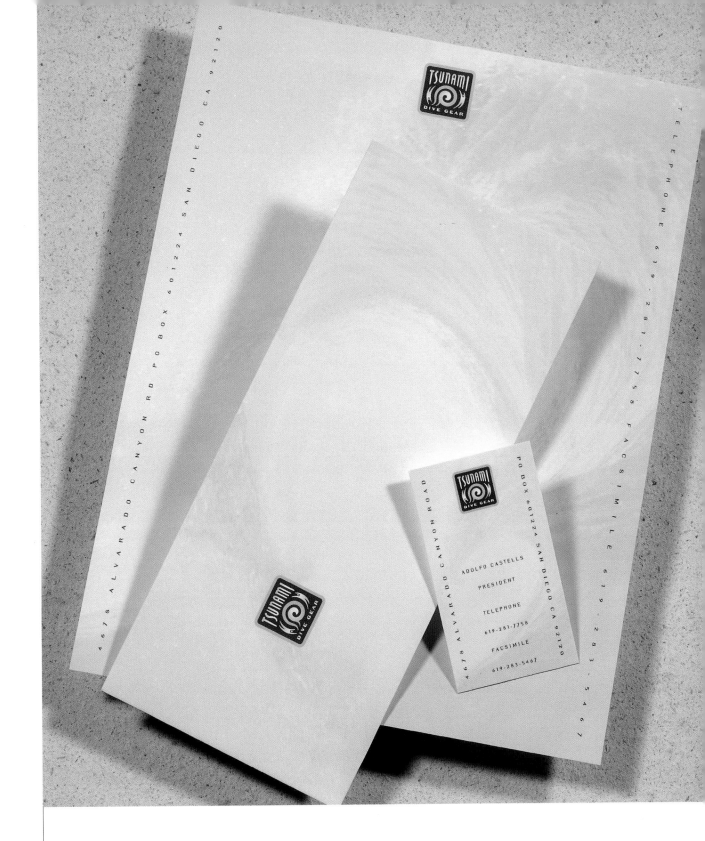

MIRES DESIGN FOR TSUNAMI DIVE GEAR

CLIENT	*Tsunami Dive Gear*
DESIGN	*Mires Design*
ART DIRECTOR	*John Ball*
DESIGNERS	*John Ball, Deborah Horn*
PHOTOGRAPHER	*Aaron Chang*

A tsunami is the seismic wave created by an undersea earthquake. It is a powerful force and a compelling name for a dive gear company. In this identity, it is used as both illustrative logo and subtle background graphic. The work as a whole has action and movement, appropriate associations for this business.

GRETEMAN GROUP FOR GRANT TELEGRAPH CENTRE

CLIENT	Grant Telegraph Centre
DESIGN	Greteman Group
ART DIRECTORS	Sonia Greteman, James Strange
ILLUSTRATOR	James Strange
DESIGNERS	Sonia Greteman, James Strange

Commercial or residential, property development is highly competitive. This nostalgic identity system with its historic flourishes creates a distinct personality. The custom-lettered logotype is configured with the address details to form a unit applied to all applications. Period details from the Centre's origin in 1896 add even more interest.

SAGMEISTER FOR NAKED MUSIC

CLIENT	Naked Music NYC
DESIGN	Sagmeister Inc.
ART DIRECTOR	Stefan Sagmeister
DESIGNERS	Stefan Sagmeister, Veronica Oh
PHOTOGRAPHER	Tom Schierlitz

This identity system for Naked Music is pared to its absolute essence; cut to the bone, you might say. The color palette is minimalist. The typography is simple. The bone is appropriately quirky. It all adds up to impact. The consistency here is in the linear arrangement of each individual graphic element.

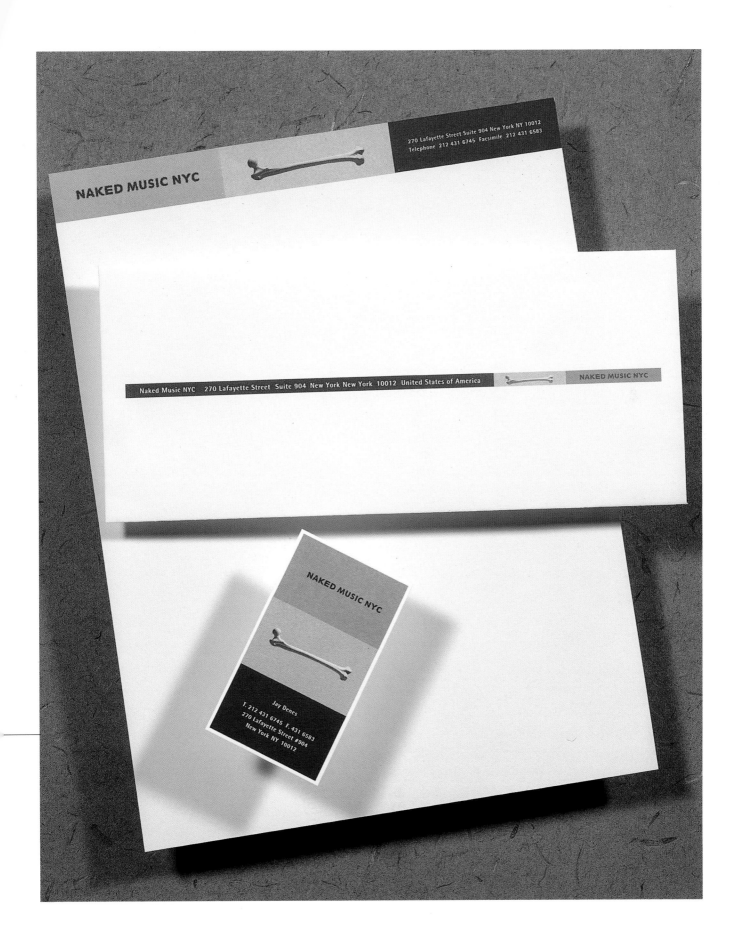

THE PARTNERS FOR EAGLE STAR INSURANCE

CLIENT	*Eagle Star Insurance*
DESIGN	*The Partners*
PROJECT DIRECTOR	*Louisa Cameron*

For over 100 years, the Eagle Star identity was built around a stern illustrated eagle. At first glance, this new logo looks entirely star-focused. A second look reveals the suggestion of an eagle's head at the star's top. It's very subtle; a graphic wink with humor and approachability— important (and rare) attributes for an insurance company.

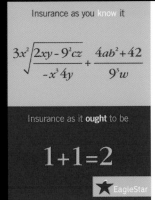

Insurance as you know it

$$3x^2 \sqrt{\dfrac{2xy - 9^2cz}{-x^3\,4y}} + \dfrac{4ab^2 + 42}{9^3 w}$$

Insurance as it **ought** to be

$$1 + 1 = 2$$

EagleStar

We've
updated
your
car
insurance policy

EagleStar

Your
home
insurance
documents

A summary of the benefits

How do we
stand
out
in a crowded market?

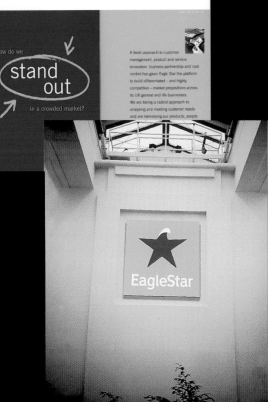

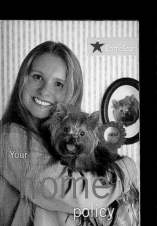

Your
home
policy

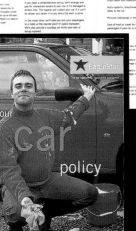

Your
car
policy

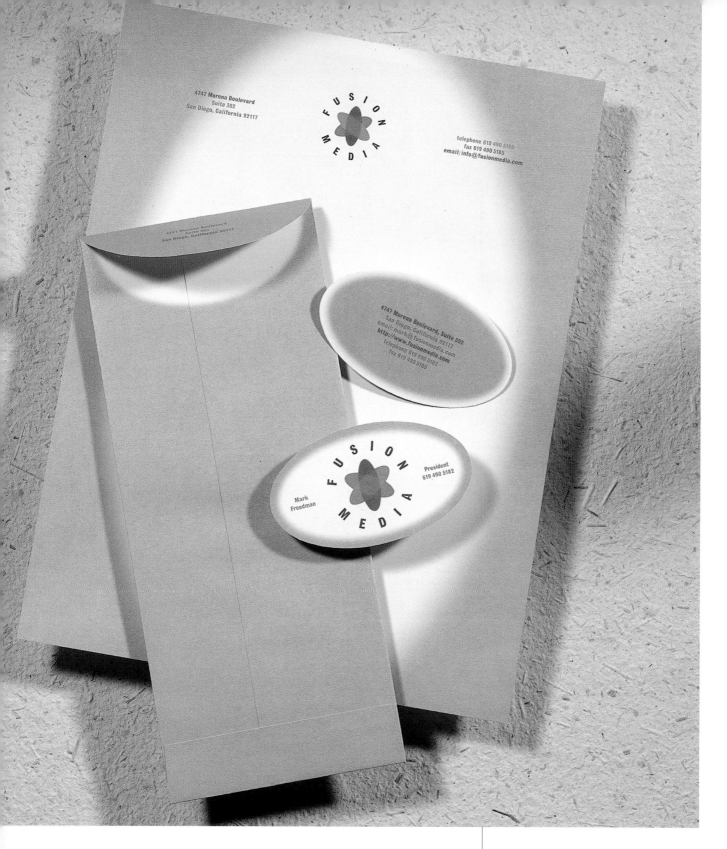

MIRES DESIGN FOR FUSION MEDIA

CLIENT	*Fusion Media*
DESIGN	*Mires Design*
ART DIRECTOR	*John Ball*
DESIGNERS	*John Ball, Deborah Horn*

This multi-colored logo is a fanciful graphic representation of the birth of atomic energy. It is a playful, creative, and appropriate symbol for this new media company. There is consistency in almost every element, especially in the elliptical shapes found on or in each application. (Note the envelope flap and unusual business card.)

PLATINUM DESIGN FOR PLATINUM DESIGN

CLIENT	*Platinum Design, Inc.*
DESIGN	*Platinum Design, Inc.*
ART DIRECTOR	*Victoria Stamm*
DESIGNER	*Victoria Stamm*

This identity is understated elegance personified. A relatively straightforward logotype combines with minimal graphic elements to communicate the maximum about this firm's name. It also says volumes about their approach to design. Again, that's one of the goals of any corporate identity: to speak well of you in your absence.

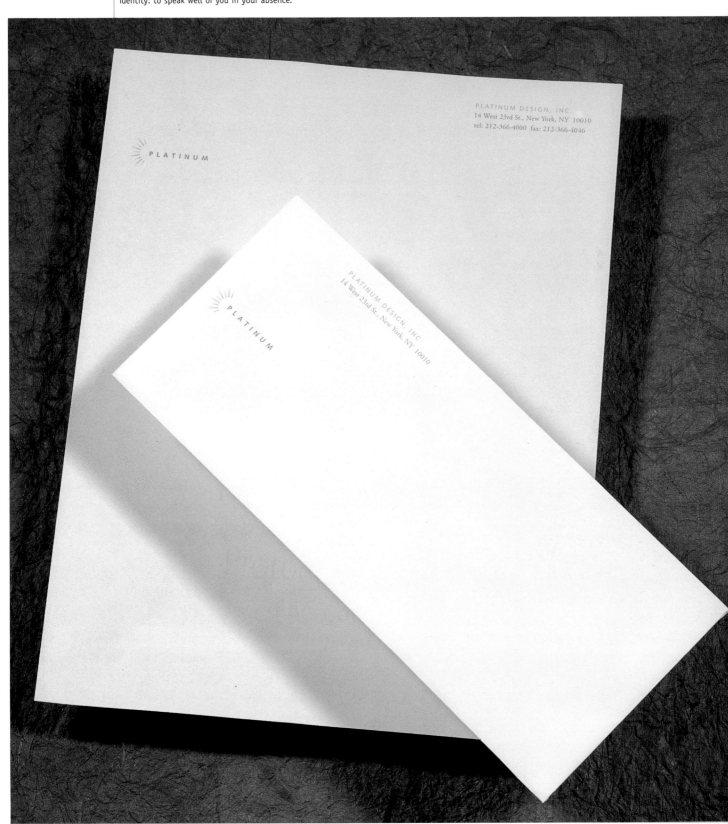

VOSS DESIGN FOR CURT RICHTER FRANIA

CLIENT | *Curt Richter Frania, Artist-Agency*
DESIGN | *Voss Design*
ART DIRECTOR | *Axel Voss*
DESIGNER | *Axel Voss*

The Frania agency was founded just before the roaring twenties in Germany, the home of cabaret. The elegant script typography and vintage advertising images used in this identity evoke the days of big bands, top hats, and diaphanous gowns. The agency's talent offerings—from combos to acrobats—border the smaller applications.

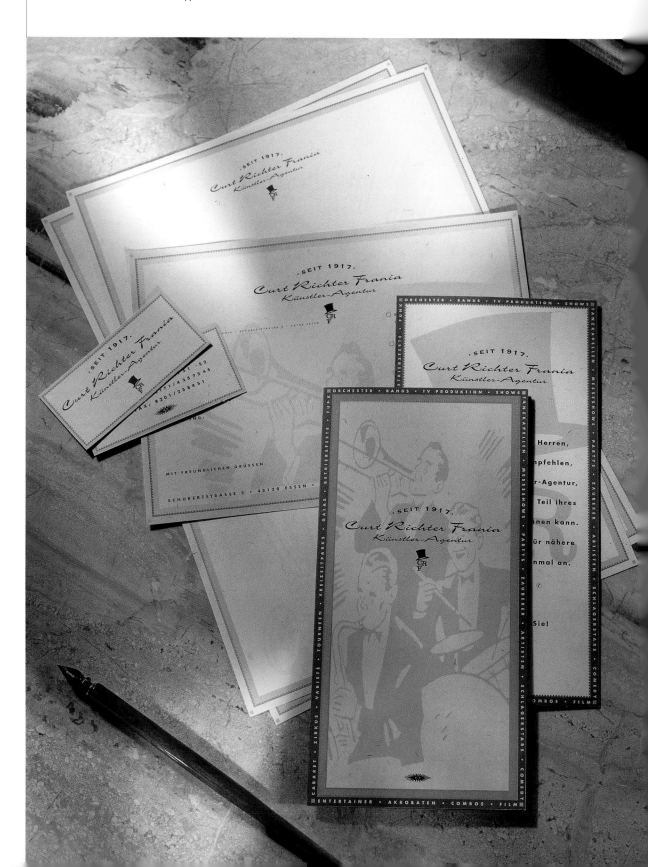

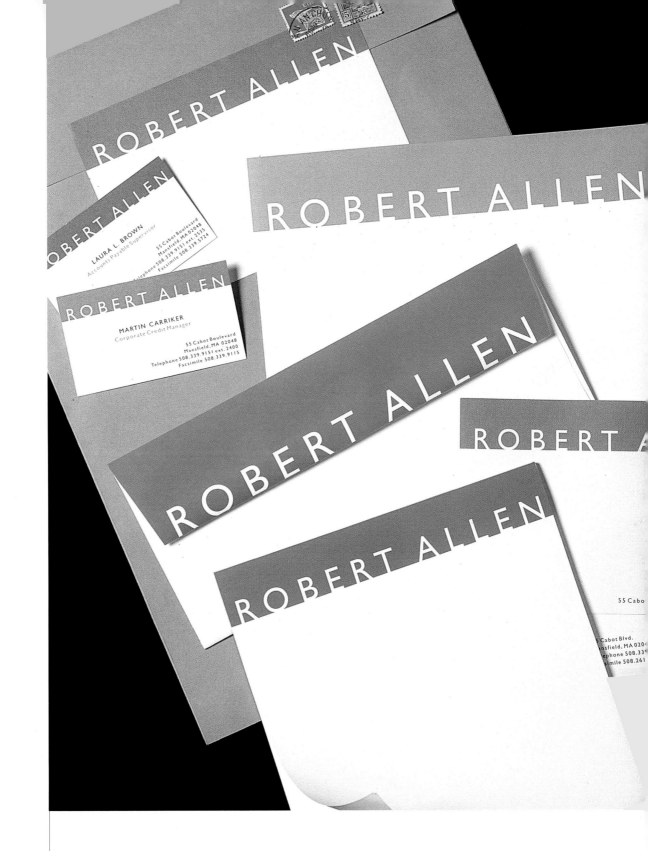

SUSAN SLOVER FOR ROBERT ALLEN

CLIENT	*Robert Allen Contract Fabrics*
DESIGN	*Slover and Company*
ART DIRECTOR	*Susan Slover*
DESIGNER	*Tamara Behar*

A simple logotype solution with the slightest hint of
cropping provides the foundation for this appropriately
fashionable identity system. The color palette is muted,
reflecting the classic character of Robert Allen. This palette
paves the way for a range of multi-colored applications.

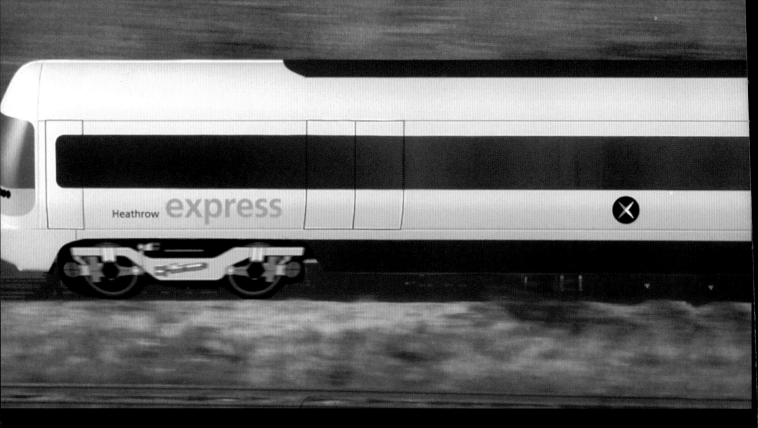

WOLFF OLINS FOR HEATHROW EXPRESS

CLIENT Heathrow Express
DESIGN Wolff Olins
ART DIRECTOR Ian McArdle
DESIGNERS Adam Throup, Jeremy Tankard, Robert Wood,
Simon Fraser, Adrian Reed, Martin Hargreaves,
Colin Leisk, Robert Elliston, Peter Brown
PHOTOGRAPHER Duncan Smith

The mark created by Wolff Olins for this high-speed train to
and from London's Heathrow airport is both simple and
distinctive. Conceptually, it suggests getting there in a
flash. There's a practical aspect, too. Because it lends itself
to embossing, tickets are difficult to counterfeit. A single
color expressing high-tech energy completes the
branding process.

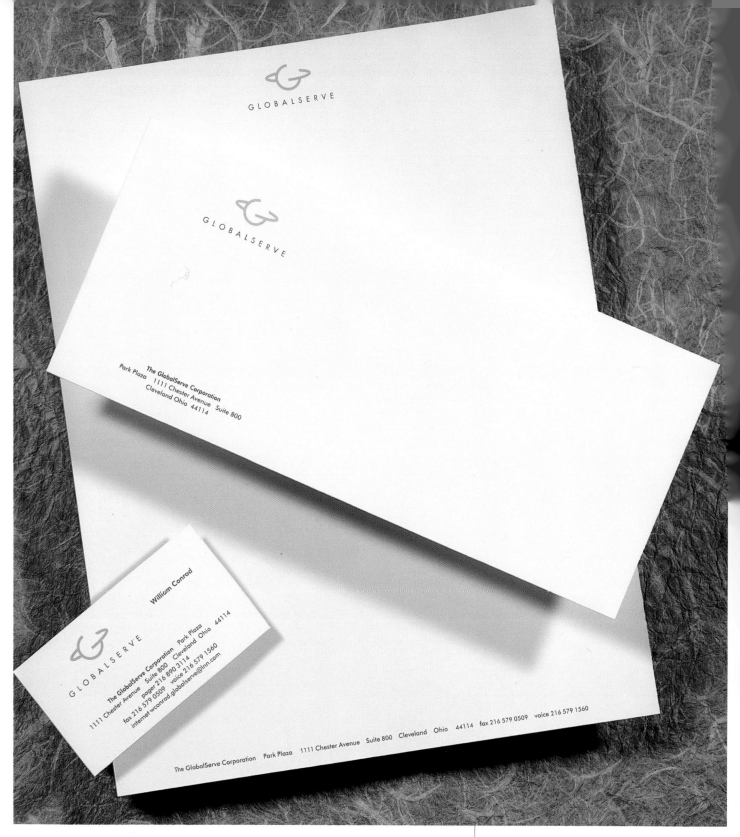

NESNADNY & SCHWARTZ FOR THE GLOBALSERVE CORPORATION

CLIENT *The GlobalServe Corporation*
DESIGN *Nesnadny + Schwartz*
ART DIRECTOR *Gregory Oznowich*
DESIGNER *Gregory Oznowich*
ILLUSTRATOR *Gregory Oznowich*

This is a clean, simple identity system made to seem larger with an expanse of white space. The logo's effectiveness lies in what it leaves to the imagination. Take the unclosed loop around the globe. The mind's eye completes the picture, but the opening itself is unexpected. This is what makes the logo interesting.

GRAFIK COMMUNICATIONS FOR MAJOR LEAGUE SOCCER PLAYERS

CLIENT | *Major League Soccer Players Association*
DESIGN | *Grafik Communications*
DESIGNERS | *Jonathan Amen, David Collins, Judy Kirpich*

This identity system is sensitive to cost and visual impact.
The logo is illustrative and literal. The layout, like the identity,
is playful but works hard. Note how the compartmentalized
information is the system's consistent graphic element. The color
palette is more limited than it seems. The pocket folder is
standard; only the label is printed.

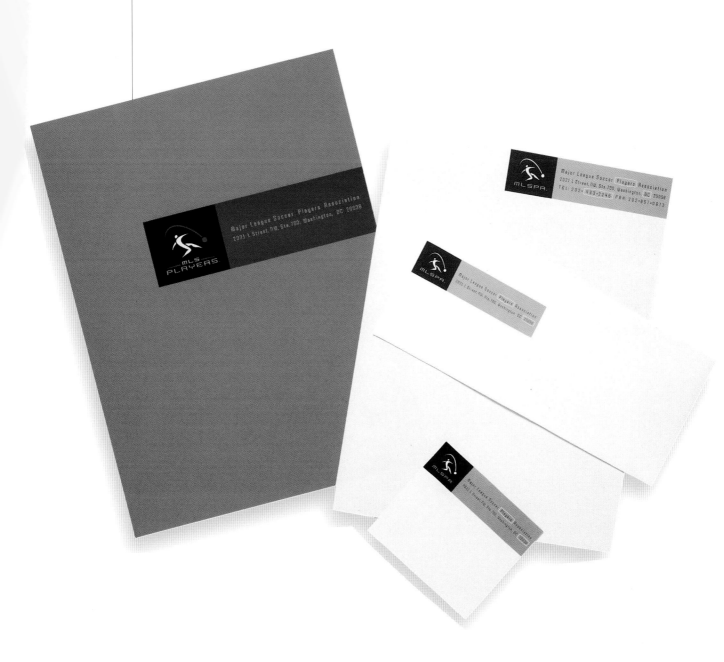

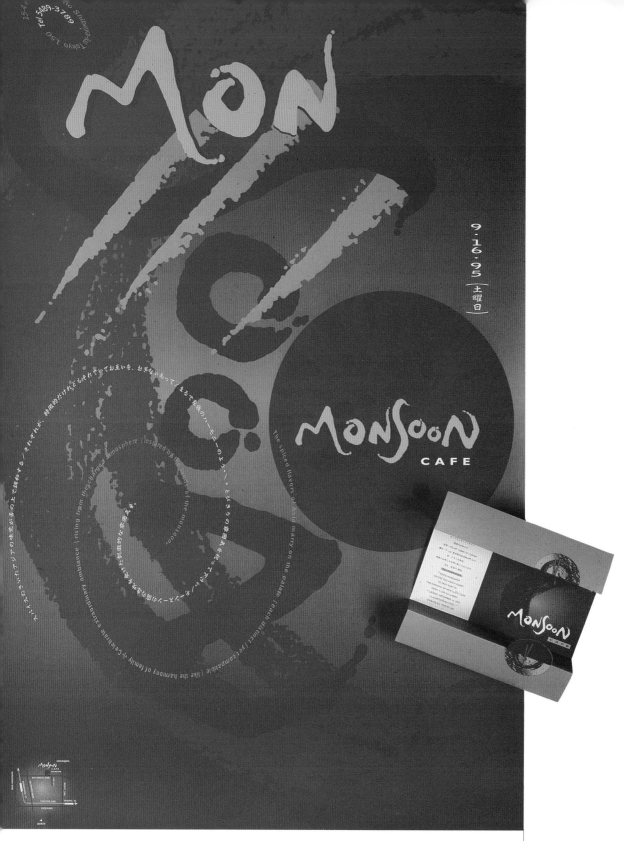

VRONTIKIS DESIGN FOR MONSOON

CLIENT	*Hasegawa Enterprise Ltd.*
DESIGN	*Vrontikis Design Office*
ART DIRECTOR	*Petrula Vrontikis*
DESIGNER	*Kim Sage*
ILLUSTRATOR	*Christina Hsiao*

The movement in this identity evokes the tropical winds and rains for which the restaurant is named. The logo and its accompanying graphics swirl around and around a surprisingly vibrant color palette. Even the typography is placed to give the impression of being caught in the rainy season.

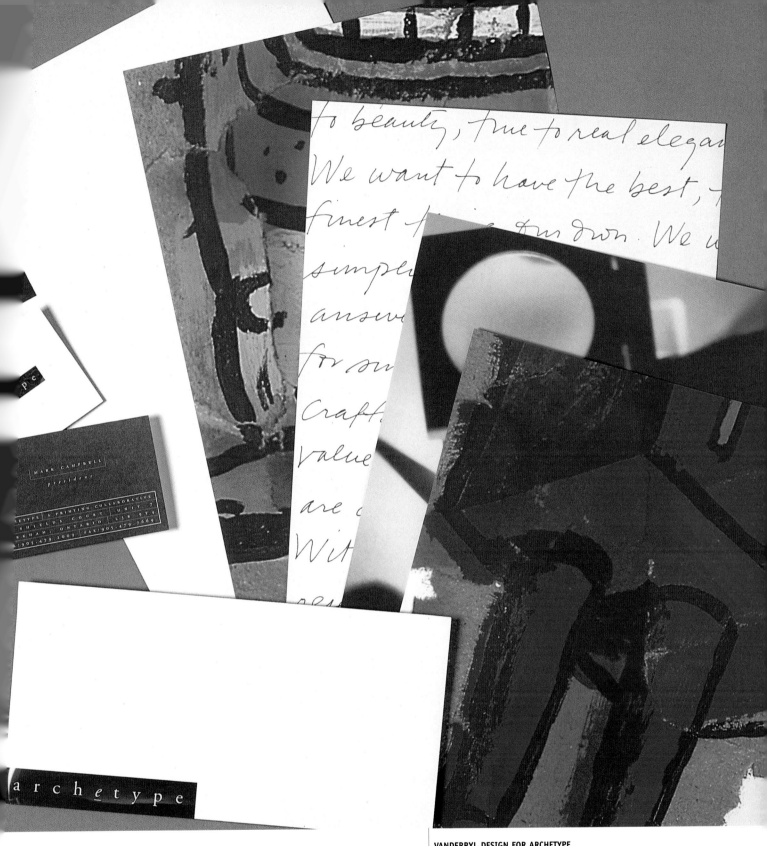

VANDERBYL DESIGN FOR ARCHETYPE

Client	Archetype
Design	Vanderbyl Design
Art Director	Michael Vanderbyl
Designer	Michael Vanderbyl

A printer's corporate identity must show two things: appreciation for design and pure printing skill. This work succeeds at both. The logotype itself is straightforward, with a single letter customized for distinction. The backs of the letterhead carry "portfolio" pieces demonstrating the printer's crafts manship. It's beautiful and strategically sound.

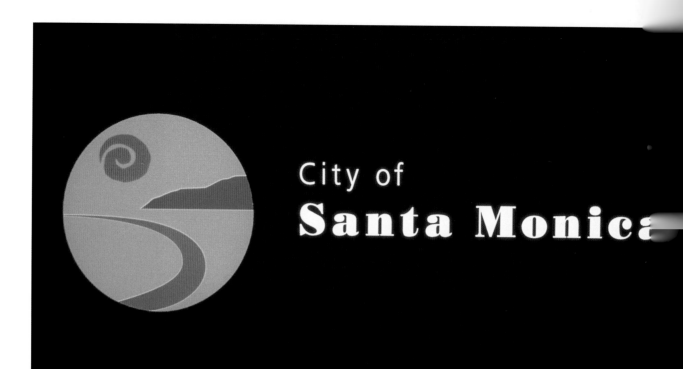

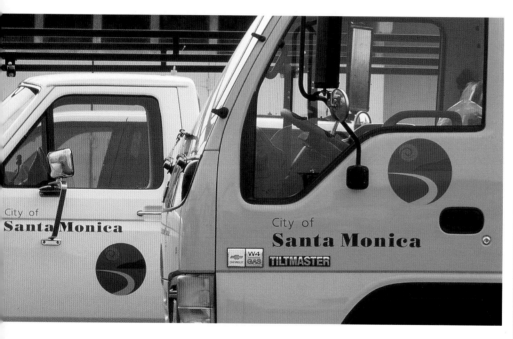

SUSSMAN PREJZA FOR THE CITY OF SANTA MONICA

CLIENT *The City of Santa Monica*
DESIGN *Sussman/Prejza & Company, Inc.*

A beautifully simple, evocative symbol is the heart of this identity and signage system. The logo references the sun, sea, and mountains that are all part of the Santa Monica landscape. The color palette for the symbol and all applications is bright and colorful, again reflecting the city's character.

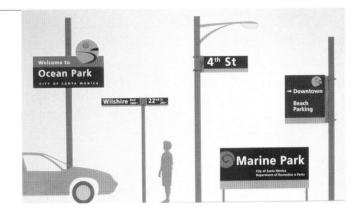

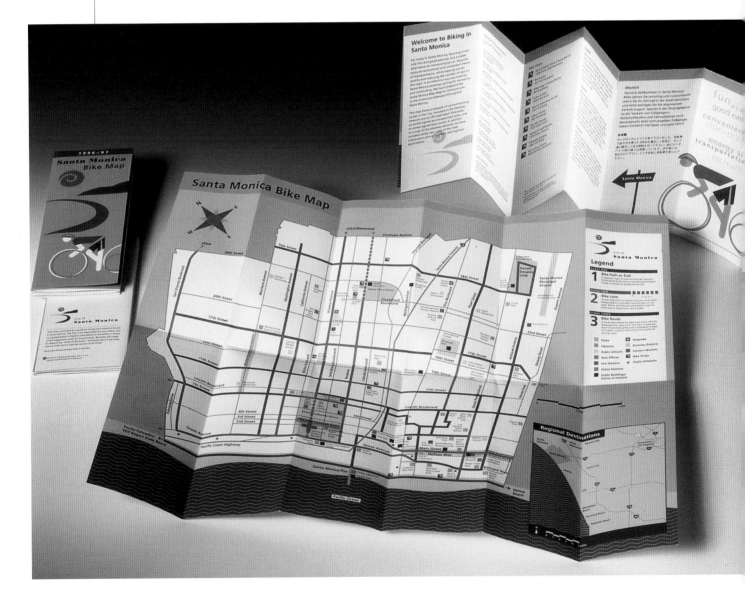

Pesona Pictures Sdn Bhd
159A Jalan Aminuddin Baki
Taman Tun Dr Ismail
60000 Kuala Lumpur *Malaysia*
Tel 603 719 1602 ✦ 718 2316
Fax 603 719 1586

Studio
24 Jalan Kemajuan 12/18
46200 Petaling Jaya
Selangor Darul Ehsan *Malaysia*
Tel 603 754 2334 ✦ 754 2276
Fax 603 754 2335

Pesona Pictures Sdn Bhd
159A Jalan Aminuddin Baki
Taman Tun Dr Ismail
60000 Kuala Lumpur *Malaysia*
Tel 603 719 1602 ✦ 718 2316
Fax 603 719 1586

Studio
24 Jalan Kemajuan 12/18
46200 Petaling Jaya
Selangor Darul Ehsan *Malaysia*
Tel 603 754 2334 ✦ 754 2276
Fax 603 754 2335

WERK-HAUS FOR PESONA PICTURES

CLIENT	*Pesona Pictures*
DESIGN	*Werk-Haus*
ART DIRECTOR	*Ezrah Rahim*
DESIGNERS	*Elrah Rahim, Wai Ming, Wee*

The simplicity of this design is part of what makes the
identity successful. It is elegant, refined, and deliberately
understated. The monogrammed logo's "watermark"
appearance on the letterhead and copper hot stamping on
each application enhances the effect. The cumulative
impact of this identity system is authority.

VISUAL DIALOGUE FOR POLLY BECKER

CLIENT	*Polly Becker*
DESIGN	*Visual Dialogue*
ART DIRECTOR	*Fritz Klaetke*
DESIGNER	*Fritz Klaetke*
ILLUSTRATOR	*Polly Becker*

This system is a letter-perfect example of identity reflecting character. Illustrator Polly Becker uses found objects and images in her work. Visual Dialogue replicated Becker's style by creating a library of stickers Becker can combine however she chooses. It's very customizable and interactive; a system with a lot of variation within a standard framework.

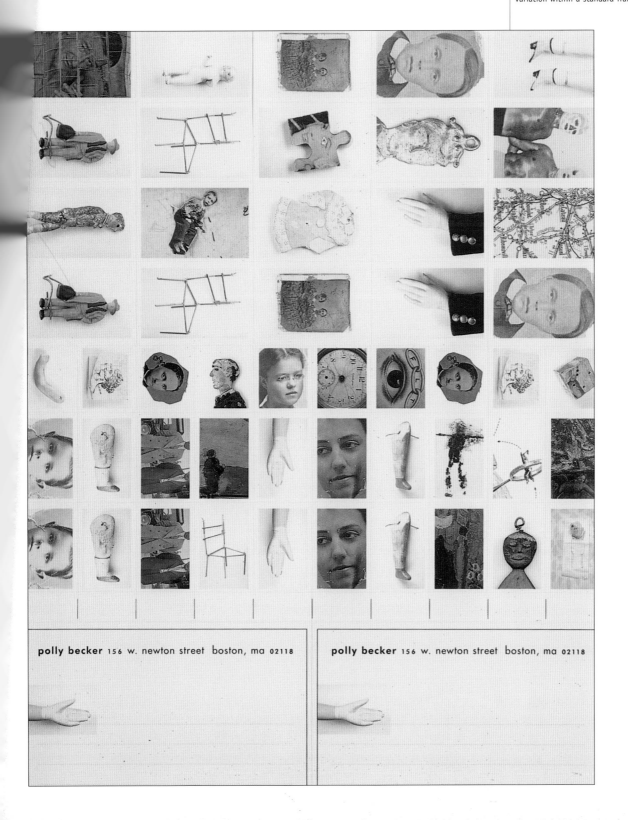

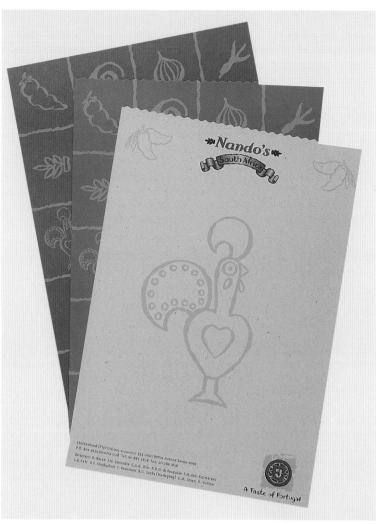

CROSS COLOURS FOR NANDO'S RESTAURANTS

CLIENT	*Nando's Restaurants*
DESIGN	*Cross Colours*
ART DIRECTORS	*Joanina Swart, Janine Rech, Adele Wapnick*
DESIGNERS	*Joanina Swart, Janine Rech, Adele Wapnick*

The primary goal in this system for a soon-to-be global restaurant chain was consistency. But it was also importa*
to convey the restaurant's Portuguese heritage and charm
The strong, rich color palette and heavy, textural papers
bring to mind the culture of Portugal. The hand-drawn fac*
and fluid supporting typography speak to the warm
Nando's spirit.

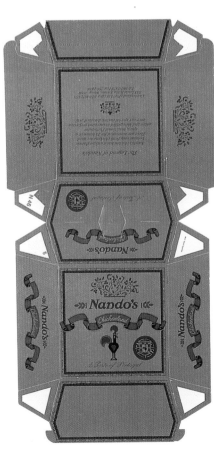

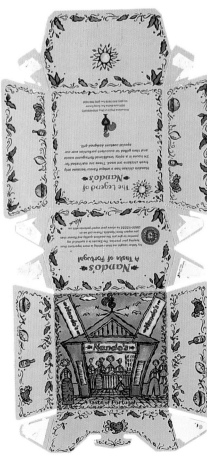

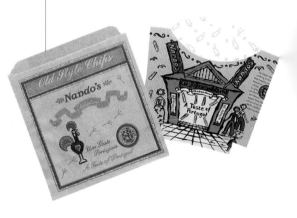

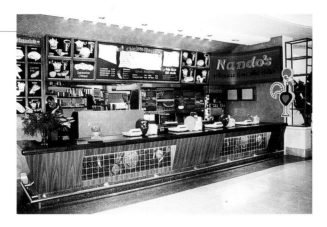

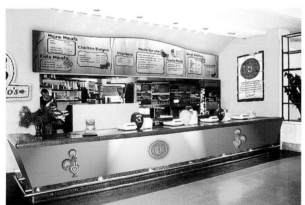

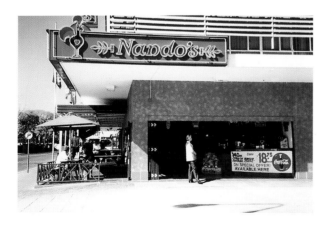

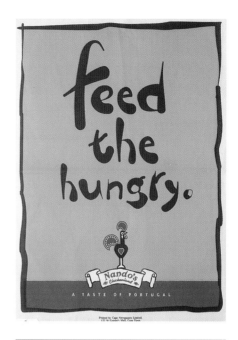

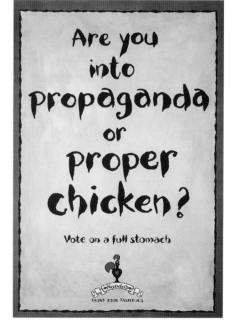

HORNALL ANDERSON DESIGN FOR XACTDATA

CLIENT *XactData*
DESIGN *Hornall Anderson Design Works, Inc.*
ART DIRECTOR *Jack Anderson*
DESIGNERS *Julie Keenan, Jack Anderson, Lisa Cerveny, Jana Wilson*

This is a creative, effective, and cost-efficient identity system—not an easy trio of attributes to pull off. Pieces were kept to only two colors, but the choices are bold and precise in keeping with the corporation's character. The first letter of the logotype can function as an icon allowing for tremendous flexibility.

FIRE HOUSE, INC. FOR CREATURES OF HABIT

CLIENT *Creatures of Habit*
DESIGN *Fire House, Inc.*
ART DIRECTOR *Gregory R. Farmer*
DESIGNER *Gregory R. Farmer*

A distinctive typeface for the logotype and generous use of vintage Americana images give this identity a busy but engaging "flea market" look. The dressmaker's form is used as a consistent free-form logo that appears in illustrative and/or photographic interpretations throughout the system. The system is pulled together by its logo, color palette, and nostalgia.

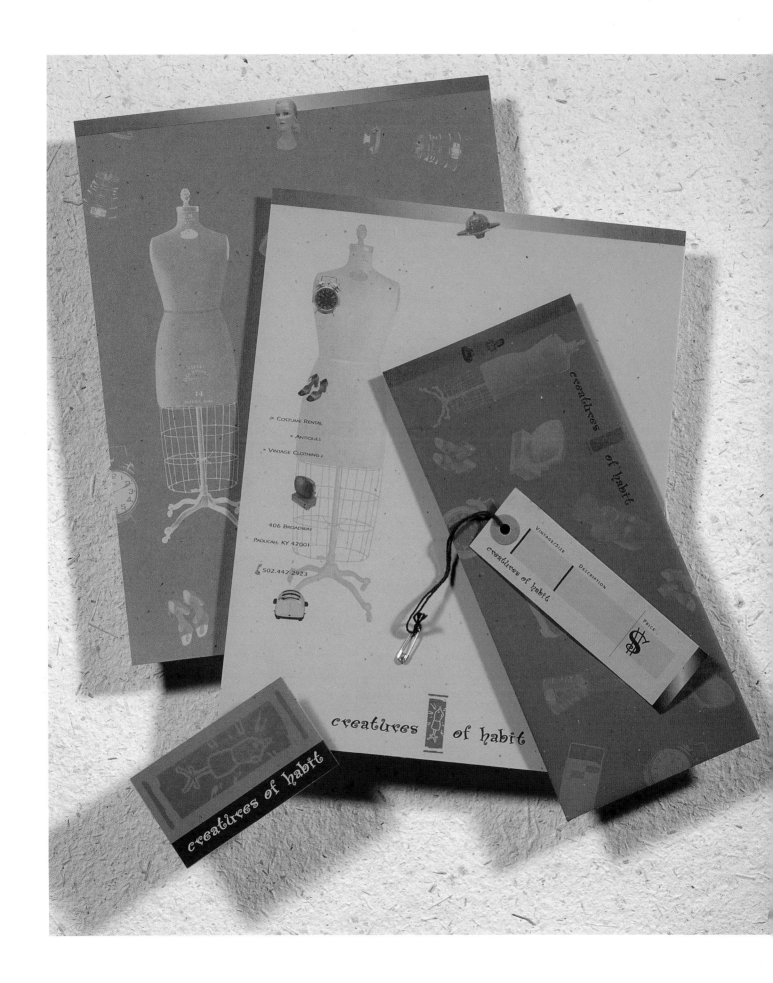

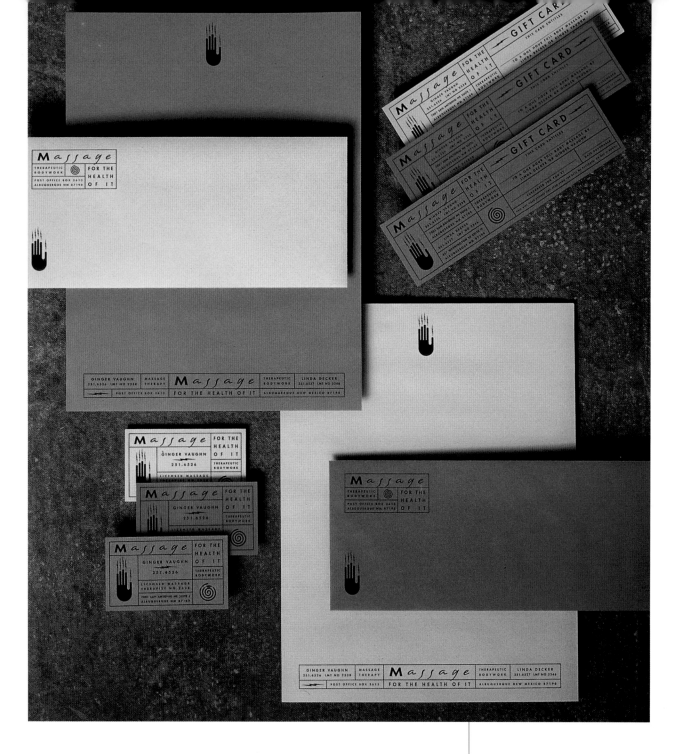

VAUGHN/WEDEEN FOR MASSAGE FOR THE HEALTH OF IT

CLIENT | *Massage for the Health of It*
DESIGN | *Vaughn/Wedeen Creative*
ART DIRECTOR | *Rick Vaughn*
DESIGNER | *Rick Vaughn*
PHOTOGRAPHER | *Michael Barley*

The message in this identity is clear: massage heals. The symbol is a hand emanating heat or power or both. The distinctive logotype used for the word "massage" carries a sense of soothing movement. Compartmentalized information gives it a sense of organization. The brilliance is in the color palette: it is made up of primary-colored papers printed with black ink.

FABRICE PRAEGER FOR TELERAMA

Client	*Télérama*
Design	*Fabrice Praeger*
Art Director	*Fabrice Praeger*
Designer	*Fabrice Praeger*

It isn't easy to take an established identity out of its medium and apply it to something as transient as gift-wrapping. Praeger's approach was to use bold typography to dimensionally recreate Télérama Magazine's logo in paper and ribbon. The logotype is deliberately overused, with variety in scale for interest. This is aggressively well-branded.

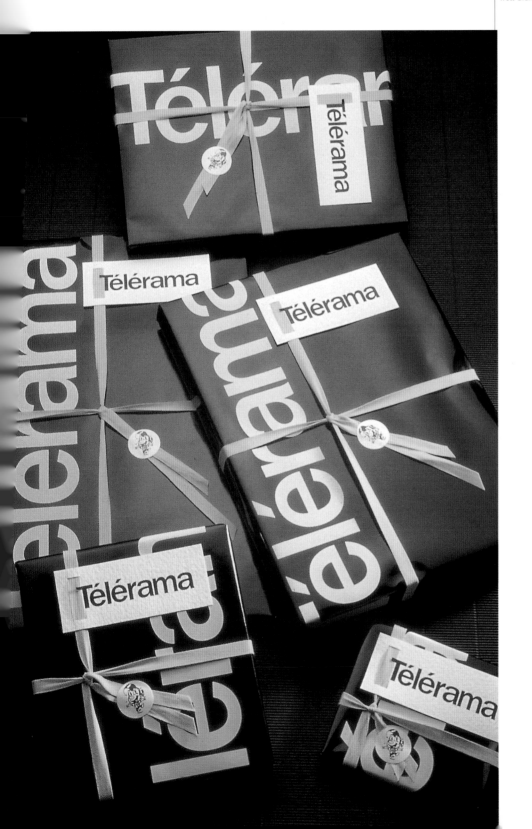

SELBERT PERKINS FOR STRIDE RITE

CLIENT | *Stride Rite*
DESIGN | *Selbert Perkins Design Collaborative*
ART DIRECTORS | *Robin Perkins, Clifford Selbert*
DESIGNERS | *Robin Perkins, Julia Daggett, Michele Phelan,*
| *Kamren Colson, Kim Reese, John Lutz*
ILLUSTRATOR | *Gerald Bustamante*
PHOTOGRAPHER | *Jim Webber*

The Selbert Perkins philosophy is simple: a company's brand and image are its greatest assets. Everything about this work supports the Stride Rite brand. The childlike logo works equally well in advertising, merchandising, and signage. Note how it becomes almost sculptural in the store. The consistent use of bright colors is a brand message in itself.

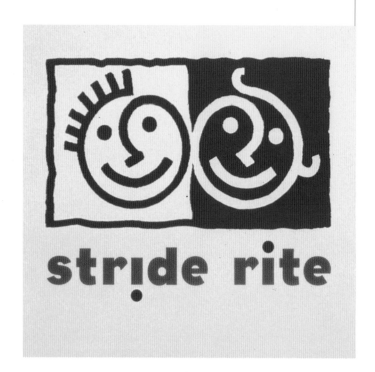

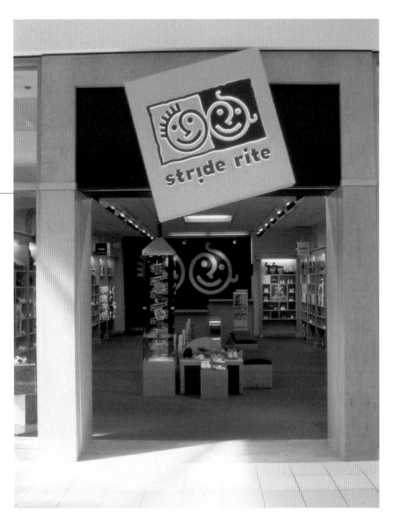

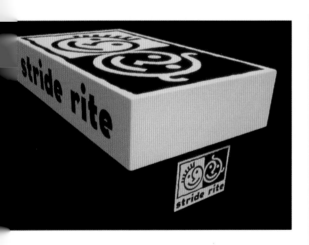

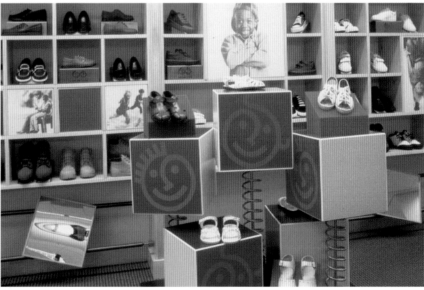

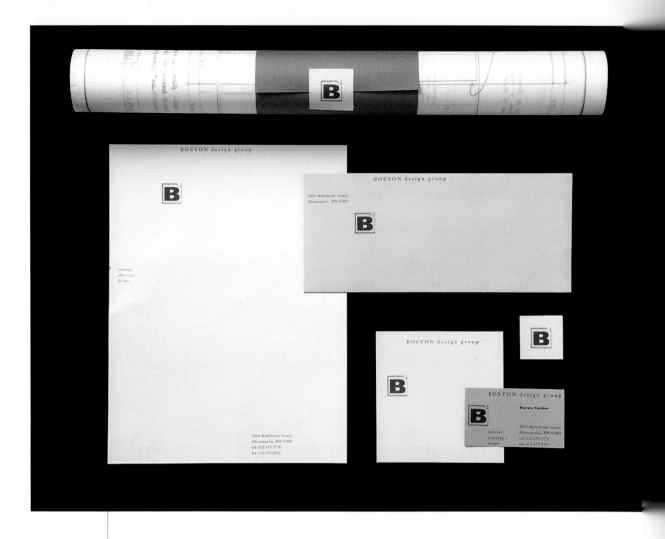

TILKA DESIGN FOR BOSTON DESIGN GROUP

CLIENT | *Boston Design Group*
DESIGN | *Tilka Design*
ART DIRECTOR | *Jane Tilka*
DESIGNER | *Carla Scholz Mueller*

The symbol anchoring this identity system works in two interesting ways. It's obviously a letterform representing the client's name. But look closely and you'll see a door opening indicated in the top right corner of the mark. This subtle point describes Boston's expertise in interior planning and gives the symbol itself a sense of scale. It's simple, sly, and very effective.

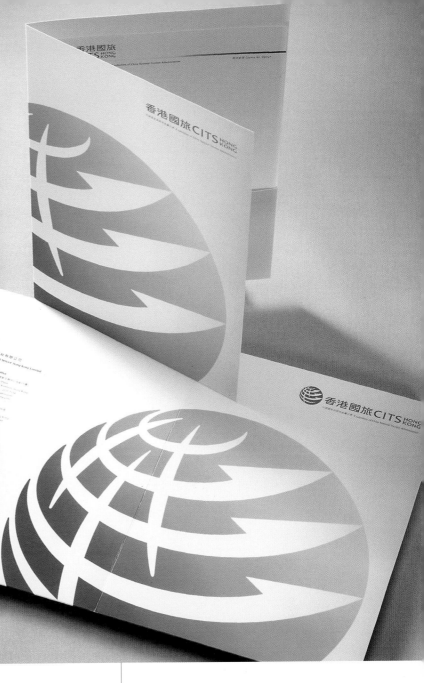

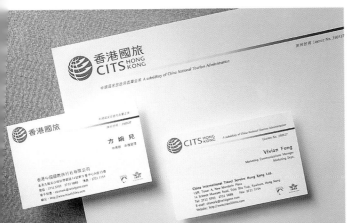

KAN & LAU DESIGN CONSULTANTS FOR
CHINA INTERNATIONAL TRAVEL SERVICE

CLIENT	*China International Travel Service*
DESIGN	*Kan & Lau Design Consultants*
ART DIRECTORS	*Kan Tai-keung, Freeman Lau, Eddy Yu*
DESIGNERS	*Eddy Yu, Veronica Cheung, Stephen Lau*

It is vital to stand out from the competition in China, but important to do so in a way that appropriately reflects a corporation's spirit. Kan & Lau's updated identity for China International Travel succeeds on several levels. The mark is fresh and dynamic; it even resembles a Chinese character for China. It speaks volumes without shouting.

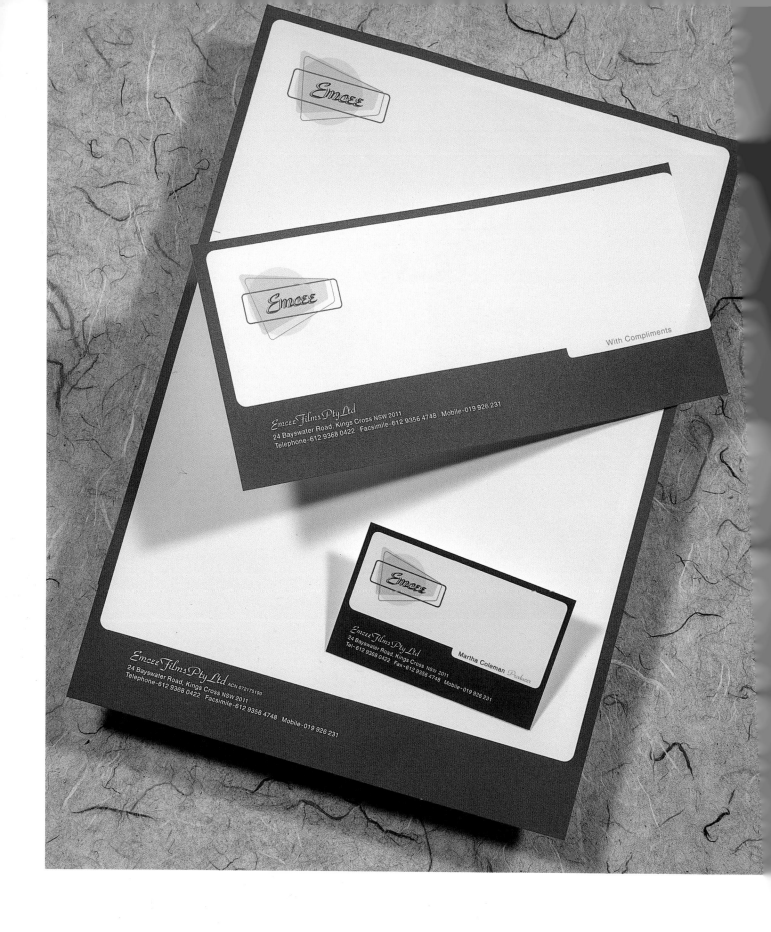

LUCY WALKER GRAPHIC DESIGN FOR EMCEE FILMS

CLIENT *Emcee Films Pty. Ltd.*
DESIGN *Lucy Walker Graphic Design*
ART DIRECTOR *Lucy Walker*
DESIGNERS *Lucy Walker*

This work by Lucy Walker for Emcee Films uses the vernacular of old drive-in movie signage. Despite its obvious nod to nostalgia, the identity feels more elegant and refined than it feels vintage. This is due in part to its contemporary color palette and sophisticated typography. All in all, a fresh use of old-fashioned equity.

"SAY AH!" CREATIVE FOR "SAY AH!" CREATIVE

CLIENT *"Say Ah!" Creative*
DESIGN *"Say Ah!" Creative*
ART DIRECTOR *Kelly D. Lawrence*
DESIGNERS *Kelly D. Lawrence*
PHOTOGRAPHER *Superstock*

There's no better compliment to creativity than to exclaim over its brilliance. "Say Ah!" Creative takes that cliché to heart, as their name, and turns it into a highly memorable corporate identity system. The handwritten logotype is supported by crisp, professional typography. One-color halftone printing on contrasting paper makes the same vintage photograph seem different in each application.

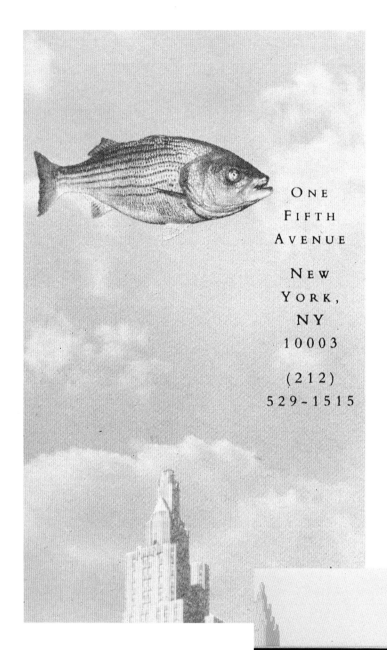

ONE
FIFTH
AVENUE

NEW
YORK,
NY
10003

(212)
529-1515

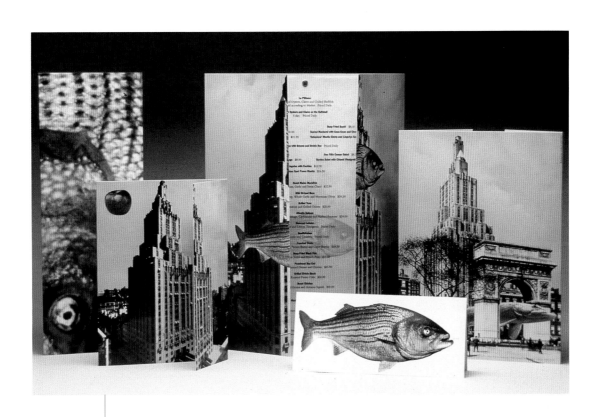

PENTAGRAM DESIGN FOR ONE FIFTH AVENUE

CLIENT	*One Fifth Avenue/Jerome Kretchmer*
DESIGN	*Pentagram Design*
ART DIRECTORS	*Paula Scher, James Biber*
DESIGNER	*Ron Louie*
PHOTOGRAPHER	*Peter Mauss/Esto*

New York has more restaurants per capita than almost any
city in the world. Image is essential to survival there. This
rich, elegant, intriguing identity for One Fifth Avenue rises
above the competition literally and figuratively. A kit of
parts including vintage photography gives it consistency. If
the restaurant lives up to this work, it is a winner.

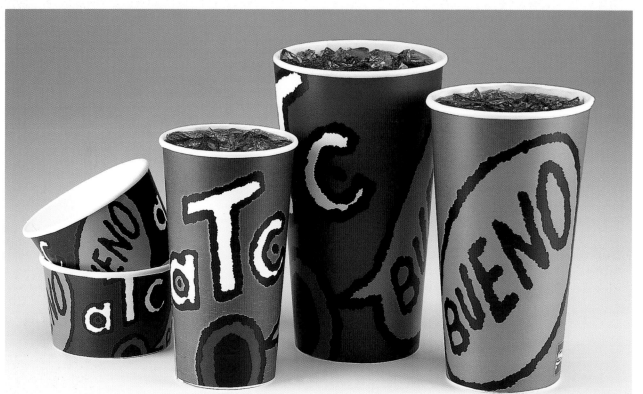

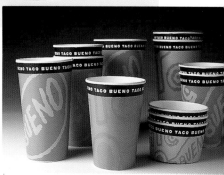

PENTAGRAM FOR TACO BUENO

CLIENT	*Taco Bueno*
DESIGN	*Pentagram*
PHOTOGRAPHER	*Lowell Williams*

Branding, thy name is consistency. Taco Bueno's identity from store to store was consistent primarily in its old-fashioned logotype and low-key color palette. Pentagram's solution included a lively illustrated taco character and a fresh, bold color palette that ran through every applicatio Including the "wrappers" on storefronts.

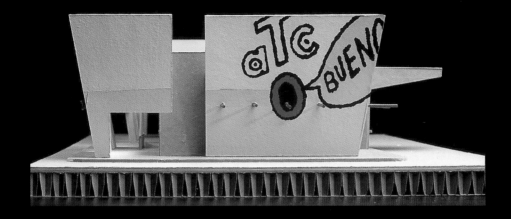

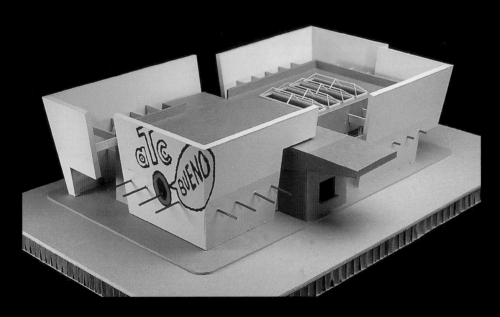

directory

20, 31 *After Hours Creative*
1201 E. Jefferson B100
Phoenix, Arizona 85034

29 *Ariel Computer Productions*
550 Queen Street East
Toronto, Ontario M5A 1V2
Canada

34 *Blok Design*
398 Adelaide W. Suite 602
Toronto, Ontario M5V 2K4
Canada

53 *Bright Strategic Design*
4223 Glencoe Avenue
Suite 223
Marina del Ray, California 90292

50 *Carré Noir*
Square Monceau
82, boulevard des Batignolles
7850 Paris Cedex 17
France

35 *Catherine Zask Design*
220. rue du Faubourg
Saint-Martin
75010 Paris
France

78 *Cross Colours*
8 Eastwood Rd, CNR Jan Smuts Ave
Dunkeld West
Johannesburg,
Republic of South Africa

17 *design guys*
119 North Fourth Street, 400
Minneapolis, Minnesota 55401

19 *Design Park*
DongSung Art Center 1-5,
Dongsung Dong,
Chongro-Gu, Seoul
Korea

21,44 *DogStar Design*
626 54th Street South
Birmingham, Alabama 35212

12 *Earthlink Creative Services*
3100 New York Drive
Pasadena, California 91107

83 *Fabrice Praeger*
54 bis, rue de l'Ermitage
75020 Paris
France

80 *Fire House, Inc.*
314 North St. Joseph Ave.
Evansville, Indiana 47712

71 *Grafik Communications*
1199 North Fairfax Street, Suite 700
Alexandria, Virginia 22314

29, 60 *Greteman Group*
142 N. Mosley, 3rd Floor
Wichita, Kansas 67202

11 *Halapple Design & Communications*
1112 Ocean Drive, Suite 203
Manhattan Beach, California 90266

8, 23, 26, *Hornall Anderson Design Works, Inc.*
58, 80 1008 Western Avenue, Suite 600
Seattle, Washington 98104

52, 87 *Kan & Lau Design Consultants*
28/F Great Smart Tower
230 Wanchai Road
Hong Kong

16, 47 *Karacters Design Group*
777 Hornby, Suite 1600
Vancouver, B.C.
Canada

48 *Lewis Moberly*
33 Gresse Street
London W1P 2LP
England

89 *Lucy Walker Graphic Design*
Level 5
15-19 Boundary Street
Rushcutters Bay
Sydney, NSW 2011
Australia

24 *Matteo Bologna Design NY*
142 West 10th Street, #2
New York, New York 10014

59, 64 *Mires Design*
2345 Kettner Blvd
San Diego, California 92101

40 *Morla Design*
463 Bryant Street
San Francisco, California 94107

50 *Mother Graphic Design*
Level 5
15-19 Boundary Street
Rushcutters Bay
Sydney, NSW 2011
Australia

70 *Nesnadny + Schwartz*
10903 Magnolia Drive
Cleveland, Ohio 44106

32 *Nestor-Stermole Visual
Communications Group*
19 W 21st #602
New York, New York 10010

15, 91 *Pentagram Architectural Services*
204 5th Avenue, Suite F11
New York, New York 10010-2102

92 *Pentagram Design, Austin*
1508 West 5th Street
Austin, Texas 78703

65 *Platinum Design*
14 W 23rd Street
New York, New York 10010

46 *Prime Studio*
326 7th Ave
New York, New York 10001

8 *Russell, Inc.*
119 Spadina Avenue, Level 5
Toronto, Ontario, M5V 2L1
Canada

7, 22, 39, *Sagmeister, Inc.*
42, 54, 60 222 W. 14th Street, #15A
New York, New York 10011

89 *"Say Ah!" Creative*
515 Broad Street
Menasha, Wisconsin 54952

84 *Selbert Perkins Design*
1916 Main Street
Santa Monica, California 90405

11 *Siebert Design*
1600 Sycamore Street
Cincinnati, Ohio 45210

68 *Slover and Company*
584 Broadway, Suite 903
New York, New York 10001

45 *Smullen Design*
85 N. Raymond Ave, Suite 280
Pasadena, California 91103

55 *Storm Design*
1321 Hastings Cr SE
Calgary, Alberta
Canada

30 *Studio Hill*
417 Second Street SW
Albuquerque, New Mexico 87102

the Authors

Dianna Edwards is a freelance writer and the last true native living in Atlanta, Georgia. She admits to being "an unabashed regionalist" and has written for and about Atlanta's advertising and design communities for over 20 years. Her career includes work for corporate clients and publications such as *Oz, Ego, Adweek, Home*, and *Atlanta* magazines. She is a past president of The Creative Club of Atlanta, teaches Creative Writing and Ethics at The Portfolio Center and serves as co-counsel of its writing department.

Ted Fabella is Creative Director in the Atlanta office of Sapient. He has provided corporate identity, communications, and website design for a range of *Fortune 500* clients. He is the recipient of over 100 awards, including Communication Arts, Type Director's Club, and the American Center for Design. His work has been published in national and international design publications alike. Fabella is a frequent design judge and speaker, and has served on the boards of AIGA Atlanta and The Art Institute of Atlanta. He teaches Logo Design and Corporate Identity at The Portfolio Center.